The Art of
Cartooning
& Illustration

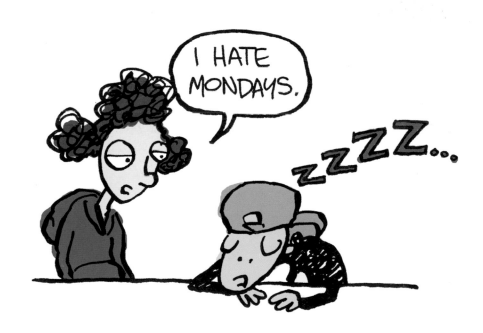

Artwork on front cover (center and bottom right), back cover, and pages 3, 8, 10–13, 18–27, 38, and 40-63 © 2014 Maury Aaseng. Artwork on front cover (top right) and pages 1, 90, and 92–111 © 2014 Alex Hallatt. Artwork on pages 4, 112, 114–126, and 128–143 © 2014 Dan D'Addario. Artwork on pages 6 and 7 © Shutterstock. Artwork on pages 14, 15 ("Mouthing Off"), 16, 17, and 29 © 2012 Joe Oesterle. Artwork on pages 15 ("The Tooth, the Whole Tooth & Nothing But the Tooth") and 28–37 © 2014 Clay Butler. Artwork on pages 64 and 66–89 © 2014 Jim Campbell.

Authors: Maury Aaseng, Clay Butler, Jim Campbell, Dan D'Addario, Alex Hallatt, Joe Oesterle
Publisher: Rebecca J. Razo
Art Director: Shelley Baugh
Project Editor: Stephanie Meissner
Associate Editor: Jennifer Gaudet
Assistant Editor: Janessa Osle
Production Artists: Debbie Aiken, Amanda Tannen
Production Manager: Nicole Szawlowski
Production Coordinator: Lawrence Marquez
Production Assistant: Jessi Mitchelar

www.walterfoster.com
3 Wrigley, Suite A
Irvine, CA 92618

Printed in China.
10 9 8 7 6 5 4 3 2 1
18461

 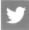

The Art of
Cartooning &
Illustration

CONTENTS

Tools & Materials .6

**CHAPTER 1: CREATING CHARACTERS WITH MAURY AASENG,
CLAY BUTLER, AND JOE OESTERLE** .9

Heads & Bodies .10

On the Face of Things. .14

Getting Handsy. .16

Playing Footsies .17

The Leading Man .18

Boy .22

Teenage Girl .24

Woman .26

Hair & Skin Tones .28

The Squash & Stretch Principle. .29

It's Alive! It's Alive!. .30

Keepin' It Real. .32

Anthropomorphism .34

Cartoon Ape .36

CHAPTER 2: SCENES & GAGS WITH MAURY AASENG .**39**

Light Bulb Gag .40

Feeding the People. .44

Bears & Park Ranger .48

Is Mars Too Far for a Tow? .52

Granny Makes Cookies. .56

The Pope, a Ninja & a Cowboy Walk into a Bar .60

CHAPTER 3: LETTERING WITH JIM CAMPBELL. .**65**

Hand Lettering .66

Formatting Text. .68

Balloons & Captions. .70

Placement & Flow. .84

Sound Effects .86

CHAPTER 4: COMIC STRIPS WITH ALEX HALLATT .**91**

Creating a Comic Strip .92

Writing for Comic Strips. .96

Comic Strip Framework . 100

Drawing the Comic . 106

CHAPTER 5: EDITORIAL CARTOONS WITH DAN D'ADDARIO.**113**

The Process. 114

At the Movies . 118

Penguin Decline . 122

Professional Dopes . 124

CHAPTER 6: CARICATURES WITH DAN D'ADDARIO. .**127**

Angelina Jolie . 128

Justin Bieber. 132

Lady Gaga . 136

Morgan Freeman . 140

ABOUT THE ARTISTS .**144**

TOOLS & MATERIALS

There is a wide range of tools and materials available for cartooning and illustration. With so many options, it's a good idea to explore and experiment to discover which you like the best! Below are some good choices to start with.

PAPER

Sketch pads and inexpensive printer paper are great for sketching and working out your ideas. Tracing paper can be useful in creating a clean version of a sketch using a light box. Just be sure to use quality tracing paper that is sturdy enough to handle erasing and coloring. Card stock is sturdier than thinner printer paper, which makes it ideal for drawing on repeatedly or for heavy-duty artwork. You may also want to have illustration board on hand.

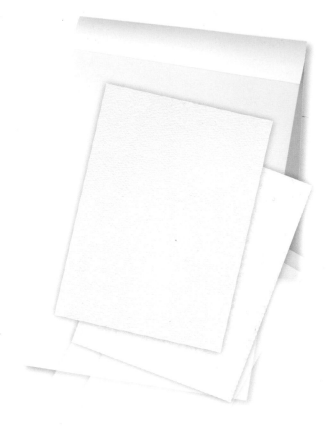

PENCILS

Pencil lead, or graphite, varies in darkness and hardness. Pencils with a number and an H have harder graphite, which marks paper more lightly. Pencils with a number and a B have softer graphite, which makes darker marks. A good pencil for sketching is an H or HB, but you can also use a regular No.2 pencil.

ERASERS

Vinyl and kneaded erasers are both good to have on hand. A vinyl eraser is white and rubbery and is gentler on paper than a pink eraser. A kneaded eraser is like putty. It can be molded into shapes to erase small areas. You can also lift graphite off paper to lighten artwork.

INDIA INK

India ink is black ink made of carbon. It is a traditional inking material for comic book artists.

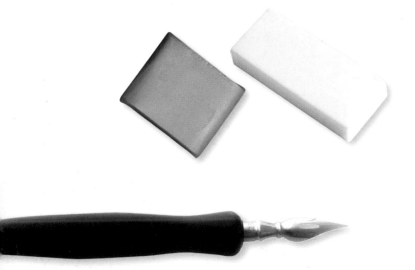

QUILL OR DIP PEN

Quill and dip pens provide some flexibility with line when inking. You can purchase different sizes of nibs. Be careful when inking with these tools. They often leave lines that stay wet for several minutes. Make sure you allow for plenty of drying time!

MARKERS

Most cartoon and illustration work is colored digitally today, but if you'd rather use traditional materials, art markers are perfect for adding bold, vibrant color to your artwork.

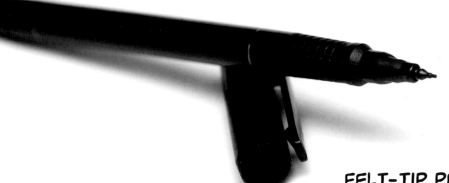

FELT-TIP PEN OR FINE LINE MARKER

Use a black felt-tip (or fiber-tip) pen or fine line marker to tighten your lines and ink your final pencil illustrations.

TEMPLATES & RULER

You can find circle, ellipse, and curve templates at any art supply store. These templates are perfect for making dialog balloons. You'll also find it handy to keep a ruler nearby. For lettering your illustrations you should also have a T-square, set squares, and Ames guide (see page 66).

DIGITAL TOOLS

The majority of professional cartoon and illustration work is finished digitally, but don't worry if you're not set up for this. You can still create beautiful full-color illustrations using markers, colored pencils, or even paint. If you want to give digital illustration a try, you'll need your computer, a scanner, and image editing software such as Adobe Photoshop®.

CHAPTER 1

CREATING CHARACTERS

WITH MAURY AASENG, CLAY BUTLER, AND JOE OESTERLE

There is no end to the number of cartoon characters the creative human mind can dream up. Cartoon characters can be as real or as exaggerated as you—the cartoonist—want them to be!

In this chapter you'll learn how to use basic shapes and forms to create a variety of head and body shapes and how to generate myriad expressions with facial features and hands and feet. You'll learn how to create a cartoon character from start to finish, including adding color!

You'll also get a quick look into how to use exaggeration appropriately to convey different types of people, as well as how to bring inanimate objects to life and apply humanlike characteristics to animals.

Turn the page to get started in your cartooning adventure!

HEADS & BODIES WITH MAURY AASENG

Much of a character's personality can be captured with the initial act of picking a simple shape. A shape serves as the blueprint for a cartoon's body or head and embodies much of the attitude and feeling that your character will convey. Different shapes can suggest different things. For instance, a shape with sharp angles can suggest an angry or intense person. Wide, round shapes can suggest a comfortable inertia within the character. A strange shape often sets the stage for a character who is awkward. Sometimes you may have a character in mind, and you draw a shape to fit their personality. Other times it can be fun to just draw a shape on your paper and then figure out what kind of character jumps out. Try as many different shapes as you can; you may be surprised at the variety of characters that live in your head!

HEADS

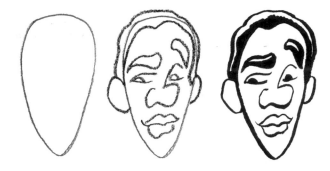

A fat carrot shape sets the stage for a strong-jawed, confident man. The shape of the head alone suggests that a tall, lean body accompanies the character's face.

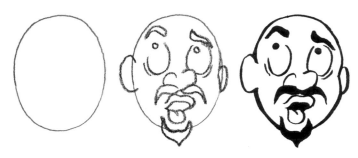

A large, wide oval provides the meaty head of a what could be a singing opera star, a chatty barber, or maybe a pizza maker calling for a "PICK UP!".

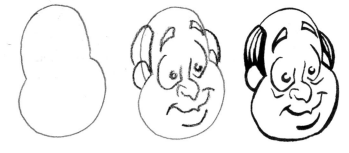

Drawing a pear shape gives me the dome-headed and big-cheeked basis for this smiling character. Adding some jolly features to his face, along with the remnants of a hairdo, and this fellow has the look of a happy butler.

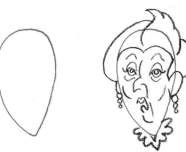

An upside-down teardrop serves as a beginning point for a stodgy British countess. The upward-pointing "bump" of the teardrop is echoed by the upturned nose, eyebrows, widow's peak, and lips to give the lady a bit of a stuck-up appearance.

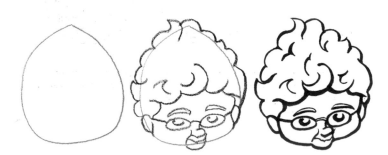

In contrast, look at what a down-turned (and wider) teardrop shape can render. The large, pointy half provides ample room for this kindly woman's hair, and her gentle features and wide cheeks occupy the bottom of the teardrop.

An asymmetrical, boxy shape provides the basis for a tilted head. Though I round the edges, you can see how the features of this slightly arrogant gum-chewer originated along my initial shape's edges.

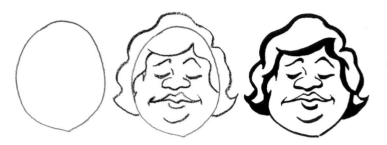

A large and proud woman can emerge out of wide oval with a pointed bottom tip. Her closed eyes and lips and a maintained hairstyle reflect a woman with a no-nonsense attitude and some self respect!

An elongated trapezoid provides the shape of an exhausted and yawning man. An asymmetrical shape for his mouth and vertically stretched eyes suggest the bizarre look of a face when captured mid-yawn!

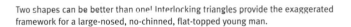

To draw a bitter wizard (a la Rasputin), I start with a skinny and hooked teardrop shape. The shape's pointed tail becomes the twisted beard, the bulbous top becomes a bald head, and a hooked nose fits with the sharply curved shape.

Two shapes can be better than one! Interlocking triangles provide the exaggerated framework for a large-nosed, no-chinned, flat-topped young man.

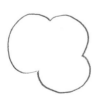
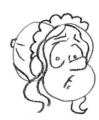

Here I just made a strange popcorn-like shape and tried to make a face out of it. One bump became the cheek, another bump became the forehead, and the third bump became the bonnet of this disturbed housemaid.

An infant's features are about as round as they come, so I start with an imperfect circle as the basis for this bawling baby's head. I want the focus on the crying mouth, so I draw the nose and eyes minimally in comparison.

BODIES

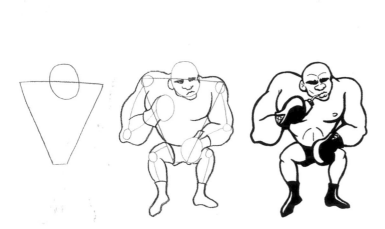

BOXER By beginning my cartoon with a circle intersecting an inverted trapezoid, I create the powerful body and wrecking-ball head of an intimidating boxer. To create his limbs, I draw lines with circles marking the joints before adding the beefy flesh surrounding them. While completing his features, I add some tough-guy features, such as a lumpy nose, thick bottom lip, and eyebrows so dark and thick they hide his eyes.

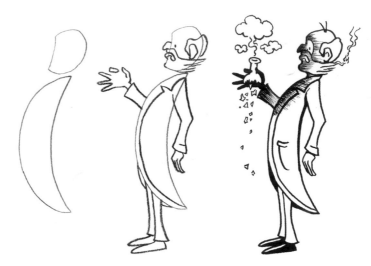

SCIENTIST A banana shape for the body is perfect for this absent-minded scientist. The inward-sloping back suggests movement and surprise. I draw an oval with one flat side for the head and add arms, legs, hands, and facial features, including a beard. All that's left to add is the broken vial, some smoke, and dark hatch lines to illustrate how this genius "got burned" by an experiment gone wrong.

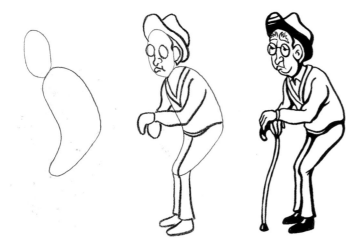

ELDERLY MAN A boomerang shape creates the sloping back of this hunched-over octogenarian. I just use a simple, elongated oval for the head and then sketch in his limbs, hat, and facial features. After adding bushy eyebrows, thick glasses, and a rubber-tipped cane this guy's ready to hit the bingo hall!

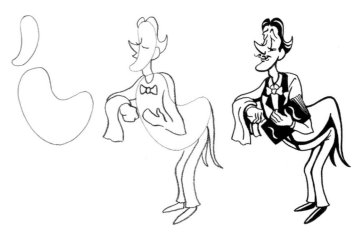

WAITER For this cartoon, I start with two abstract, curved shapes floating near each other (one marking the head, the other the body). After connecting the shapes with a noodlelike neck, accompanied by noodlelike legs and arms, my waiter character begins to take shape. His desperate-to-please appearance is heightened by his exaggerated posture, silly tuxedo, and the swoop of hair and tiny mustache.

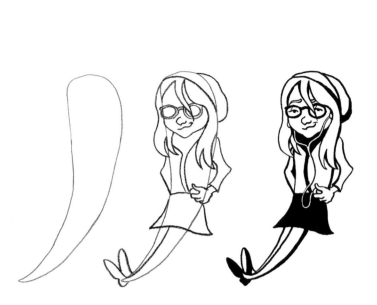

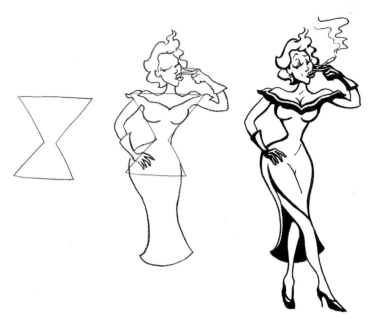

HIPSTER A chili pepper might seem an unlikely place to begin, but it captures the posture of this young hipster. I add an arm off to one side, and the tip of the chili becomes indistinct legs leaning on a wall. The top half of the chili morphs into a girl's head wearing a floppy hat, dark-framed glasses (likely non-prescription), Indie-music-playing earbuds, and a smug expression. If only her parents understood her.

GLAMLADY Seductive femme fatales are usually drawn with an hourglass shape to mark their body—it's this shape that gives them their power! I then hang the curved lines that make arms, legs, body, and head off this initial shape, using it as a template. I finish up by adding the details (pointy heels, cigarette holder, sly expression) that complete her mischievous image.

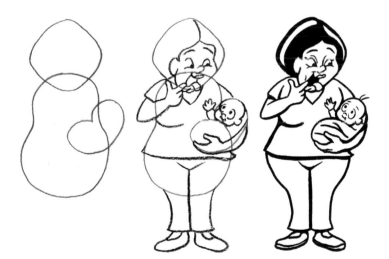

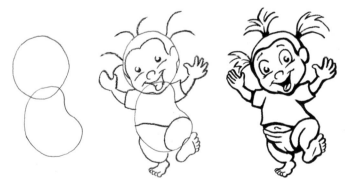

MOM I start this goofy mom with a peanut-shaped body and a rounded diamond for the head, adding a lima-bean-shaped baby body near where her arm will go. These shapes are perfect for helping me flesh out the arms, legs, hair, and facial features on mom, plus the big baby head. This new mom will do anything to keep baby happy, including making funny faces!

TODDLER A lima bean with a large circle on top creates the framework for a rambunctious toddler. By adding short and stubby legs, outstretched hands, and placing the face at a tilted angle I am able to create the look of a tiny kid dashing towards something (or someone) exciting. Feature details, such as three fountainlike ponytails, an exposed bellybutton, and a visible tongue, help create the expression of uninhibited enthusiasm that only a young and wound-up toddler can sustain!

ON THE FACE OF THINGS WITH JOE OESTERLE & CLAY BUTLER

Want to know the best thing about being a cartoonist? You're never wrong! (Well, at least not when you're drawing a cartoon.) Mathematicians can be wrong, scientists can be wrong, and we all know that the people who cut your hair can be wrong (and by the looks of it, they often cut mathematicians' and scientists' hair). But the beauty of being a cartoonist is that you're creating a character the way you see it in your head, so it's never wrong.

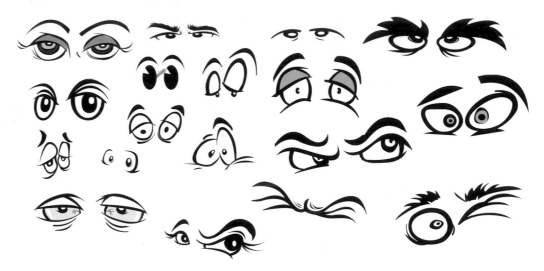

THE EYES HAVE IT

There are many ways to draw eyes: wide, narrow, squinty, droopy, crisscrossed. And just because I draw eyes a certain way doesn't mean you have to draw them that way. All in agreement just say "aye."

THE NOSE KNOWS

On its own, the nose doesn't necessarily convey emotions, but it does crinkle when it smells something bad. It elongates slightly when a face registers shock or surprise. And nostrils tend to flare when one is angry or determined. Cartoon noses can reveal a lot about a character's personality. For example, a broken nose might imply that a character is a tough guy. An upturned nose might mean a character is snooty. And a pug nose may belong to an adorable child or a hideous pigman. The moral here: Pick your nose very carefully.

I HEAR YOU

Like the nose, ears don't convey much emotion on their own. Ears can be C-shaped or V-shaped. Often they are covered, or partially covered, by hair or hats. A tough guy might have cauliflower ears. Pirates and debutantes might wear earrings. And how could a nerd hold up his bottle-lens glasses if not for his specially designed nerd ears? Now get your elbows out of your own ears and start drawing a few.

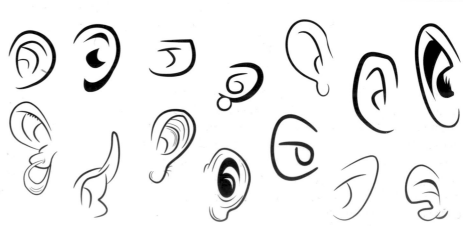

MOUTHING OFF

Perhaps the most important facial feature when trying to convey emotion is the mouth. The mouth has more working parts than the eyes or nose, giving the cartoonist more elements to play with and exaggerate. Fangs can indicate a certain type or character, such as a vampire, werewolf, or an executive secretary. Missing teeth can portray other types, such as hockey players, small children, or corporate executives. Cartoon characters' mouths can open wider than their cartoon heads. Tongues can roll to the floor when a character is surprised, or they can slobber like a great dane when a character is hungry. You can see why the mouth is a very important element in communicating!

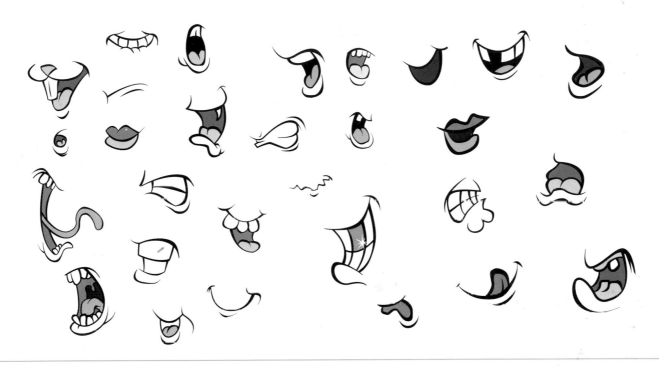

THE TOOTH, THE WHOLE TOOTH & NOTHING BUT THE TOOTH

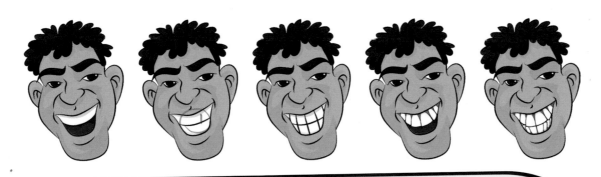

THE MORE TEETH YOU SHOW—AND THE MORE DETAILED THE TEETH—THE MORE INTENSE THE CHARACTER LOOKS

An open smile conveys a different meaning than a closed smile, as does a set of choppers. Detailed teeth make the mouth look very heavy, and the teeth look thick and clunky. There are too many teeth in a mouth to avoid this dilemma if you draw each one individually, as opposed to gesturing where the teeth are. Keep this in mind when designing characters—some may benefit from a full set of teeth, but most won't.

A THEORY TO SINK YOUR TEETH INTO
Now it's time to practice your smiles. Make a character with the simplest mouth with a single line. Then draw the same character with a full set of detailed teeth. Make one face with an open smile and one with a closed smile. How do they look? How much extra time did it take?

GETTING HANDSY WITH JOE OESTERLE

OK, show of hands. Everybody who hates drawing hands raise your right hand. Now everybody who really, really hates drawing hands raise your left hand. Allow me to share a little cartooning secret with you: Nobody likes drawing hands. Drawing hands is like eating broccoli or multiplying fractions. You don't want to do it, but it's good for you. There are numerous books and tutorials on the Internet to teach you the rules of drawing realistic hands. But who cares? We're cartoonists. We don't need no stinkin' rules.

HANDS CAN BE A COMPELLING AND PERSUASIVE WAY TO CONVEY EMOTION AND EXPRESSION.

Sure, if you want, you can draw realistic looking hands...

...or you can make your hands look like wet noodles...

...or bendable sausages.

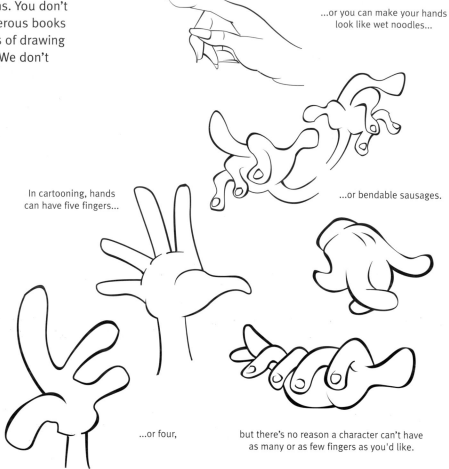

In cartooning, hands can have five fingers...

...or four,

but there's no reason a character can't have as many or as few fingers as you'd like.

HANDS COMMUNICATE...

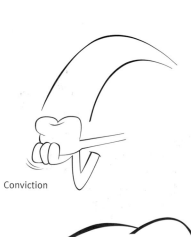

Conviction

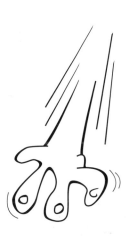

Desperation

Compassion

Explanation

Violence

Tenderness

Simply raising a hand indicates the need for a bathroom break.

PLAYING FOOTSIES WITH JOE OESTERLE

Feet can be even more fun to draw than hands because no one expects any emotion or personality from them, the lowliest of all appendages.

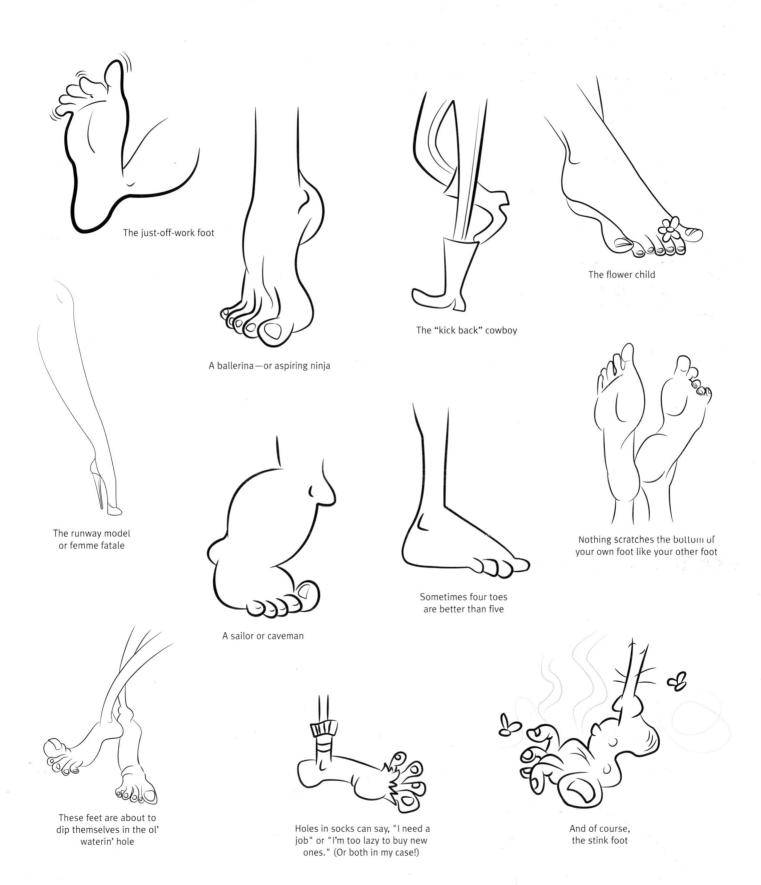

The just-off-work foot

A ballerina—or aspiring ninja

The "kick back" cowboy

The flower child

The runway model or femme fatale

A sailor or caveman

Sometimes four toes are better than five

Nothing scratches the bottom of your own foot like your other foot

These feet are about to dip themselves in the ol' waterin' hole

Holes in socks can say, "I need a job" or "I'm too lazy to buy new ones." (Or both in my case!)

And of course, the stink foot

THE LEADING MAN WITH MAURY AASENG

There are no limits to the variety of characters you can draw once you start cartooning. But it's helpful to start by drawing an archetype that surfaces again and again: the leading man. Typically square-shouldered and handsome with a winning smile, the stereotypical man seems a straightforward cartooning goal. However, even within this standard character there are infinite possibilities. A handsome prince, the international spy, the romantic Romeo, the reliable dad, and even a devious character pretending to be wholesome are all common models.

I'm going to draw a friendly Scandinavian with a bit of mischief behind smiling eyes. Despite an unpretentious sweater and friendly wave, there is something telling about the slightly cocked eyebrow and tilted head. Is he just confident, or is there something he knows that we don't?

ARTIST'S TIP

As your character continues to develop, erase the old guidelines so that only the new ones are visible. This helps keep your drawing crisp and clean.

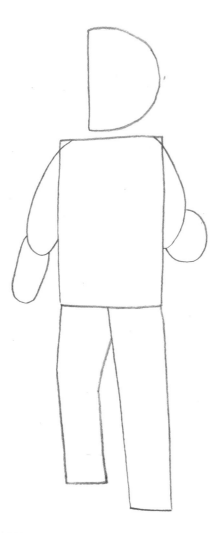

STEP 1 I start by drawing a large rectangle for his torso and a big capital "D" to mark his head placement. Then I draw elongated half-ovals for his sweater-wrapped arms and a bulbous shape at the end of each for hands. I draw straight lines for his legs.

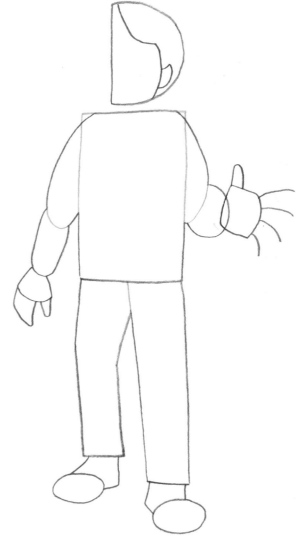

STEP 2 I draw a curved, kinked line through the head to mark the hairline and draw the small ear. I map in the hands at the end of each arm, using simple shapes for the palms and thumbs. On the left arm I make a curved shape for the fingers, and on the right hand I draw four curved lines for the fingers. I place two ovals below each pant leg to start the boots. Then I connect the ovals to the pants with a straight and angled line for each foot.

STEP 3 Next I refine some of the outer edges, or contours, of my cartoon character. I round out the sweater with more natural-looking folds and soften the outlines of the pants and boots. Then I add curved lines on the left side of the face to create his profile. I also extend the hairline on the back of the head and add two dots to mark the eyes. I draw the cuffs and collar on the sweater, and then I draw contour lines around each finger line. I erase my guidelines from my initial drawing.

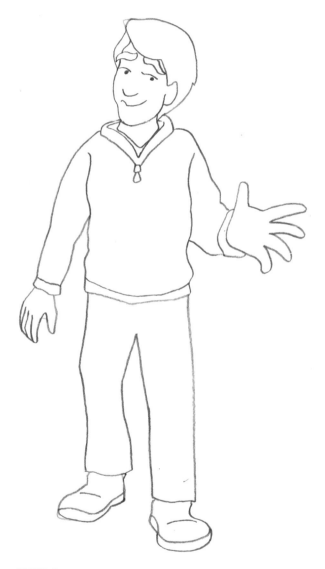

STEP 4 I continue adding detail, starting with the head. I add another curved line to the hairline to frame the face. Then I draw the eyebrows, using a shape like a dollop of toothpaste! I add two curves for his eyelids, one for the underside of his nose, and another for his bottom lip. I add the bottom hem of the sweater, as well as the collar and zipper. Then I add a line at the bottom of each shoe for the tread.

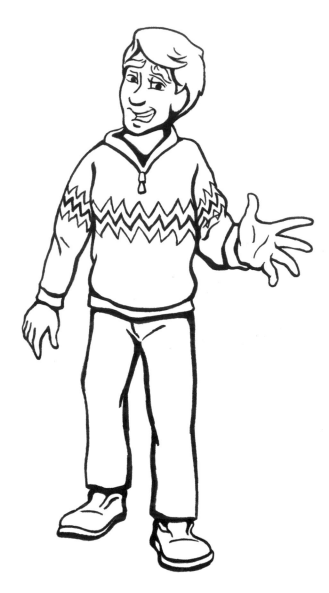

STEP 5 I add the final details on his face, the pattern on his sweater, and some clothing folds and lines on the boots. I also add a few lines in the palm of his outstretched hand and tweak the finger contours for more texture. Then I trace all my pencil lines with a fine-tipped black marker. I draw the thickest lines where I want more shadows—under his chin, in the collar, beneath his arms, and under his pant cuffs. I also add some slight thickness to the lines under his hairline, nose, and the palms of his hands to give these features dimension without competing with the darkest shadows.

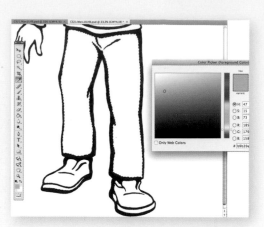

Here I've selected the pants with the wand tool. In the color picker window, I've selected the taupe color I want the pants to be.

After selecting my color, I select the paint bucket tool and click once inside my selected area. The paint bucket tool fills the pants with color.

On some areas of my cartoon, the shapes are not entirely enclosed, such as the eyebrows. To color these and stay in the lines, I use the paintbrush tool to manually color them in.

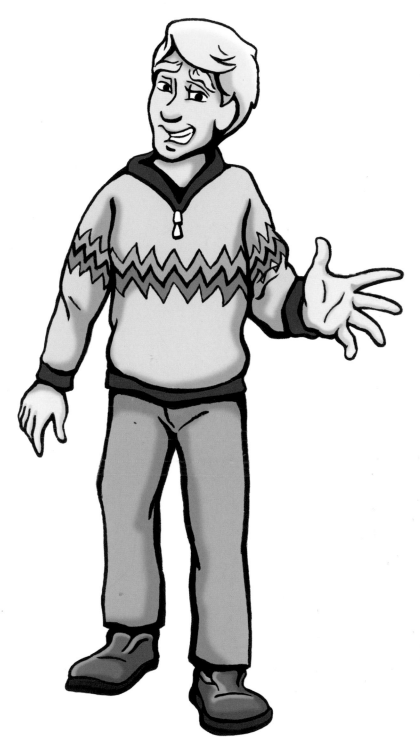

STEP 6 I scan my cartoon and digitally color it in Adobe Photoshop. I color one feature at a time by first selecting the area with the wand tool and then using the paint bucket tool to fill the area with my selected color. To add the darker shadows for depth and dimension, I use the wand tool to select areas of color that I want to shade and then select a darker version of the area's color. I use the paintbrush tool to manually color edges with my darker shade. You can also use this technique to create highlights—just select a shade lighter than your original color!

BOY WITH MAURY AASENG

Swinging from a rope in your summer trunks—unsupervised by adults, of course—over a river carries with it a reckless glee that only a boy on summer vacation can truly enjoy. Get ready to draw a cartoon of a deliriously happy kid—I submit that such a boy is the prime candidate!

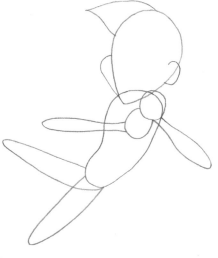

STEP 1 Because this is a more complex pose, I start with the most basic of shapes for the head and body. I draw an upside-down, tilted teardrop for the head and intersect it with a bicycle-seat shape for the body.

STEP 2 I quickly draw some simple shapes that suggest the hair, cheek, and ear on the head. I draw four elongated shapes to map the arms and legs and two circles for the hands.

STEP 3 I erase my overlapped lines and continue adding shapes to define detail on the figure. I add another pair of stretched ovals and boxy shapes to finish marking the legs and feet. Around the swoop of bangs, I add some more flamelike lines to add detail to the hair. I mark the eyes with two dots in line with the top edge of the cheeks. Then I add the long curved lines that make up the rope, with the circle at the top marking the knot.

STEP 4 Because I want to draw a "real boy" (and not a wooden one), it is time to add natural-looking contour lines to the figure. Curved lines create a more natural look for the arms and legs. I make a few quick strokes with my pencil for the swim trunks. I add the lower half of the rope, along with the suggestion of a branch at the top. I draw an upward-hooked curve for the nose and a line underneath that marks the top of the mouth. I continue to erase the old guidelines that are no longer necessary.

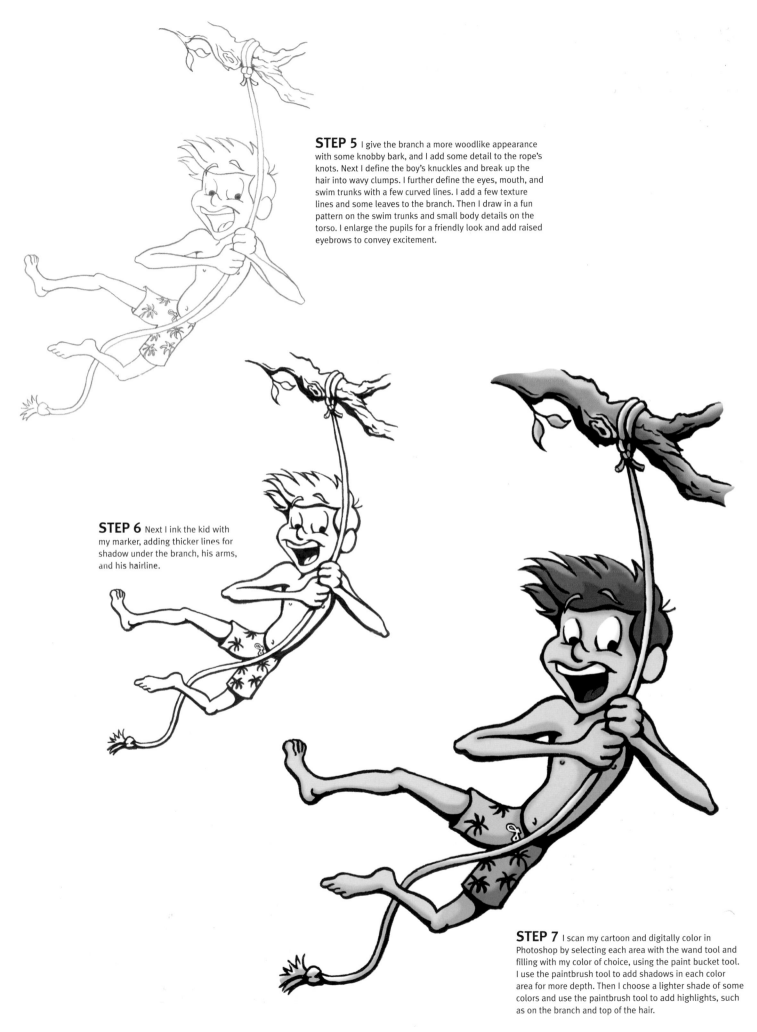

STEP 5 I give the branch a more woodlike appearance with some knobby bark, and I add some detail to the rope's knots. Next I define the boy's knuckles and break up the hair into wavy clumps. I further define the eyes, mouth, and swim trunks with a few curved lines. I add a few texture lines and some leaves to the branch. Then I draw in a fun pattern on the swim trunks and small body details on the torso. I enlarge the pupils for a friendly look and add raised eyebrows to convey excitement.

STEP 6 Next I ink the kid with my marker, adding thicker lines for shadow under the branch, his arms, and his hairline.

STEP 7 I scan my cartoon and digitally color in Photoshop by selecting each area with the wand tool and filling with my color of choice, using the paint bucket tool. I use the paintbrush tool to add shadows in each color area for more depth. Then I choose a lighter shade of some colors and use the paintbrush tool to add highlights, such as on the branch and top of the hair.

TEENAGE GIRL WITH MAURY AASENG

There are a lot of teenage girl stereotypes. Some are cheerleaders, some are artsy, and others range from gothic kids to athletes to those who just love the heck out of horses. But the humble nerd, with boundless enthusiasm for math and a blissful ignorance of style, will most likely be the one who they all call "boss" in the future. So let's give this nerdy teenage girl her due.

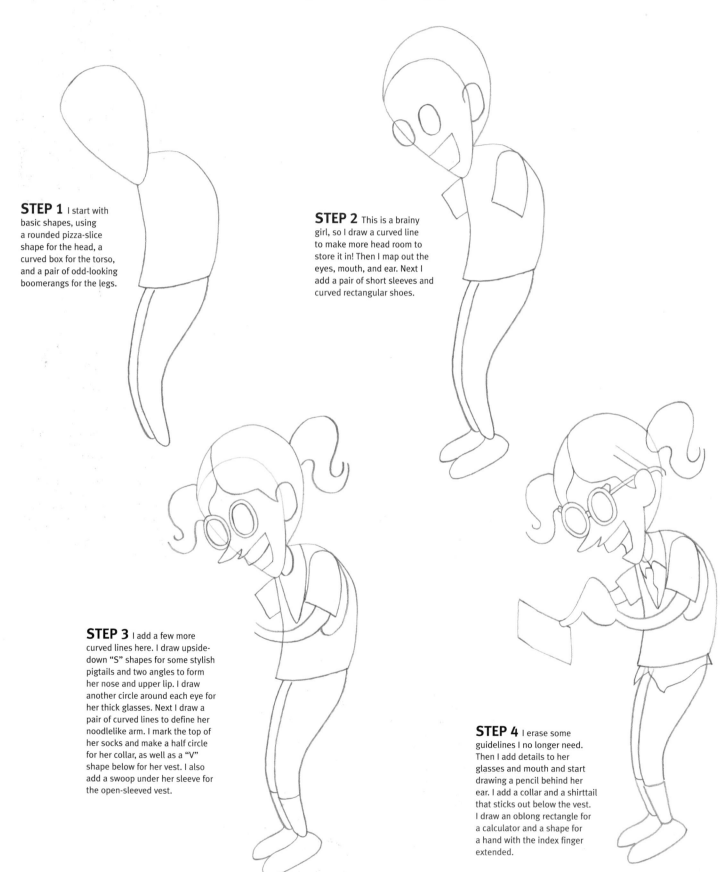

STEP 1 I start with basic shapes, using a rounded pizza-slice shape for the head, a curved box for the torso, and a pair of odd-looking boomerangs for the legs.

STEP 2 This is a brainy girl, so I draw a curved line to make more head room to store it in! Then I map out the eyes, mouth, and ear. Next I add a pair of short sleeves and curved rectangular shoes.

STEP 3 I add a few more curved lines here. I draw upside-down "S" shapes for some stylish pigtails and two angles to form her nose and upper lip. I draw another circle around each eye for her thick glasses. Next I draw a pair of curved lines to define her noodlelike arm. I mark the top of her socks and make a half circle for her collar, as well as a "V" shape below for her vest. I also add a swoop under her sleeve for the open-sleeved vest.

STEP 4 I erase some guidelines I no longer need. Then I add details to her glasses and mouth and start drawing a pencil behind her ear. I add a collar and a shirttail that sticks out below the vest. I draw an oblong rectangle for a calculator and a shape for a hand with the index finger extended.

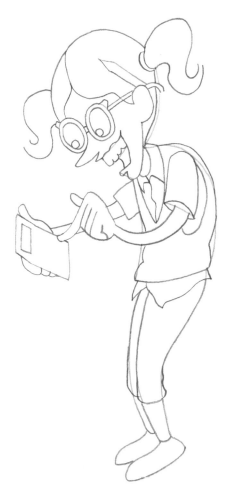

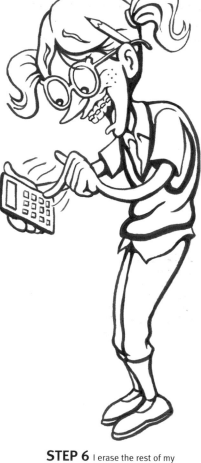

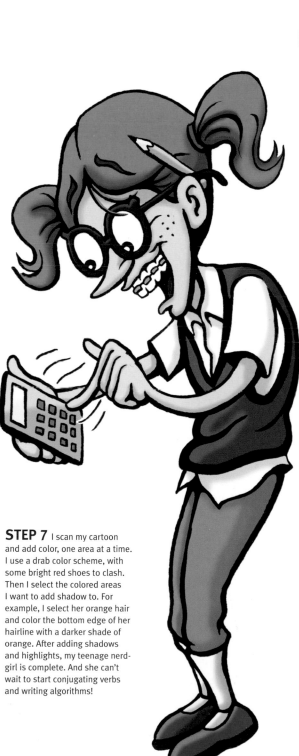

STEP 5 To give her contours a more lifelike edge and emphasize her hunched posture I draw little humps to suggest folds in her pants, vest, and shirtsleeve. I make a bumpy line to mark her teeth, and I curve the line around her lips and chin to define her face. Then I add circles for eyes, a hair tie in her pigtail, and finish the point of the pencil. I finish the second arm and draw the hand holding the calculator. I also draw dividing lines on her other hand for fingers.

STEP 6 I erase the rest of my guidelines and add the final details in pencil: freckles, braces on her teeth, and a few loose hairs on her forehead. I also add a few lines to complete her shoes, clothing, and hair, and the buttons on the calculator. I add a few motion lines around her finger to give the impression of frenetic button pushing. Then I ink my cartoon. I want the vest to appear to have a different texture than the shirt, so I use a thicker line.

STEP 7 I scan my cartoon and add color, one area at a time. I use a drab color scheme, with some bright red shoes to clash. Then I select the colored areas I want to add shadow to. For example, I select her orange hair and color the bottom edge of her hairline with a darker shade of orange. After adding shadows and highlights, my teenage nerd-girl is complete. And she can't wait to start conjugating verbs and writing algorithms!

WOMAN WITH MAURY AASENG

The modern woman is educated, confident, probably likes soy lattes, and has places to go! So let's not hold her up, and start cartooning!

STEP 1 I start with basic shapes. An egg with a ¾-curved line around it is the head and hair of my model. Then I draw an upside-down keyhole with a curved, intersecting line for the body.

STEP 2 I draw the part in her hair and a couple curved lines to indicate a bun, an ear, and her neck. Then I draw a rectangular shape and a half oval for the woman's left arm, and an oval and connecting line from the shoulder to mark her right arm. I add a second line at the waist for a belt and a few straight lines below her waist to start the legs.

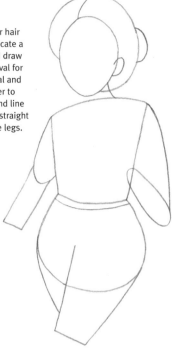

STEP 3 I detail the hairline with some curved lines from the part. Then I add some curved lines to mark the eyelids. Moving to the clothing, I draw a curved "V" shape for the opening of her cardigan. I complete the cardigan with an upside-down "V" shape that frames her hips below the belt. I mark the neckline and a couple blocks to designate the hands. Then I draw a small square for the belt buckle and a tiny circle and hooked shape to start forming her purse. I extend the pant legs down to the cuff and mark the feet with an oval for the forefront foot and a wedge for the back foot.

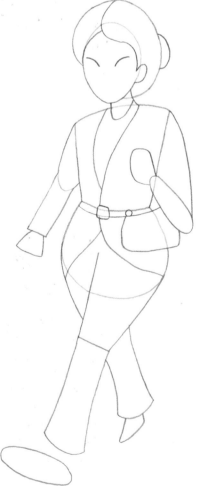

STEP 4 I erase any unnecessary lines. Then I start refining the contours of the figure by shaping the cheek, hair part, and torso. I add parallel lines to the cardigan edges to create a hem. I complete the purse, following the bottom edge of the belt. Next I add curved lines to mark the edge of her sleeves on her upper arms and another "V" shape near the neck for a necklace. I draw long tube shapes for fingers on her right hand and just a few lines to indicate those on her left. By the feet, I draw a couple curved lines to form the ankle of the left foot and a curved rectangle for the shoe on her right. I mark her eyes with a couple of dots.

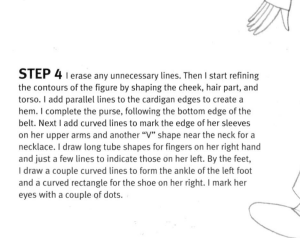

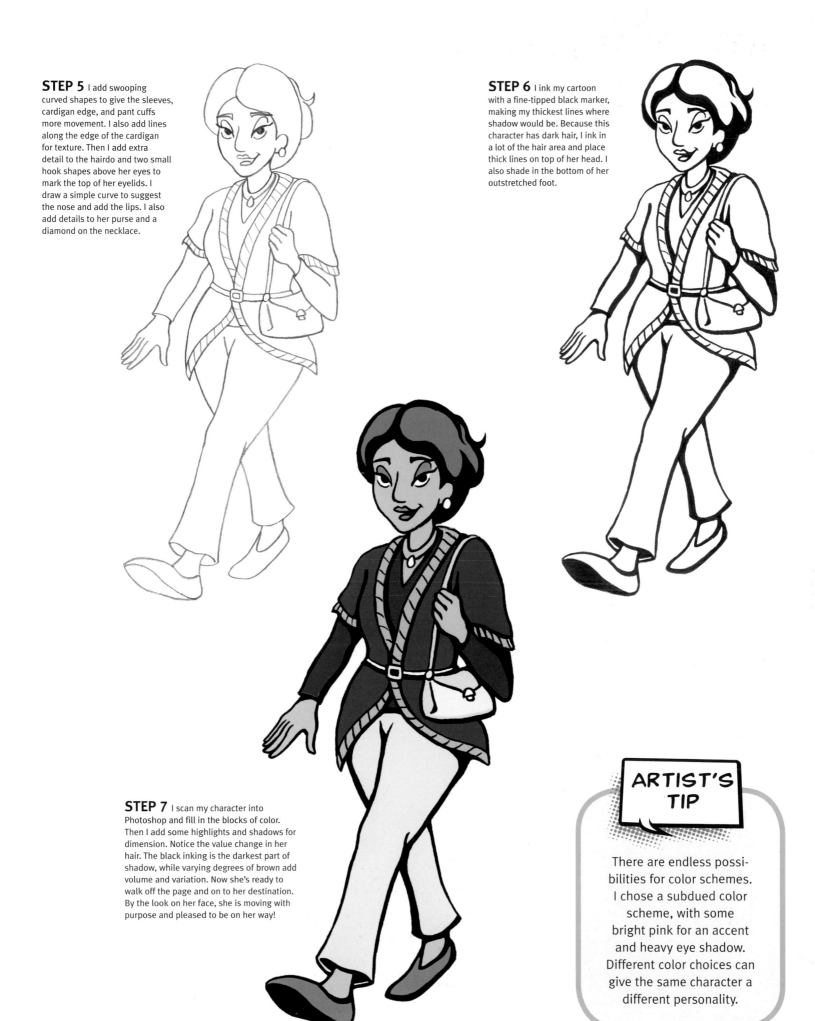

STEP 5 I add swooping curved shapes to give the sleeves, cardigan edge, and pant cuffs more movement. I also add lines along the edge of the cardigan for texture. Then I add extra detail to the hairdo and two small hook shapes above her eyes to mark the top of her eyelids. I draw a simple curve to suggest the nose and add the lips. I also add details to her purse and a diamond on the necklace.

STEP 6 I ink my cartoon with a fine-tipped black marker, making my thickest lines where shadow would be. Because this character has dark hair, I ink in a lot of the hair area and place thick lines on top of her head. I also shade in the bottom of her outstretched foot.

STEP 7 I scan my character into Photoshop and fill in the blocks of color. Then I add some highlights and shadows for dimension. Notice the value change in her hair. The black inking is the darkest part of shadow, while varying degrees of brown add volume and variation. Now she's ready to walk off the page and on to her destination. By the look on her face, she is moving with purpose and pleased to be on her way!

ARTIST'S TIP

There are endless possibilities for color schemes. I chose a subdued color scheme, with some bright pink for an accent and heavy eye shadow. Different color choices can give the same character a different personality.

HAIR & SKIN TONES WITH CLAY BUTLER

There are clear differences in hair color, texture, and body among different types of people. Through lifelong exposure to these patterns we can make fairly accurate assumptions based on hair alone. Sometimes less is more. The power of simple lines and color can convey a lot of meaning. Resist the urge to overcharacterize. Take a look at the faces below for examples of how subtle differences change a character's look.

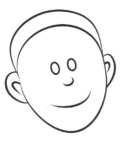 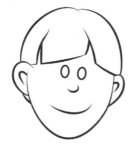

These faces have no color and are the same face shape, with the same eyes, nose, and lips; yet notice how the hair alone suggests very different types of people.

| African/Caribbean | Asian | Anglo European | Middle Eastern/Mediterranean |

Race and ethnicity can often be established with just subtle changes in the lips, nose, and hair.

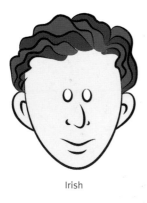 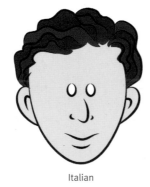 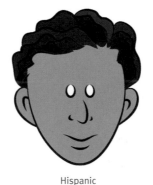 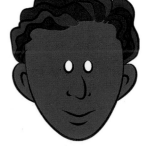

| Irish | Italian | Hispanic | Indian |

These faces are identical in all respects except for the skin tone and hair. With this change alone we can believably establish these characters as Irish, Italian, Hispanic, and Indian.

THE SQUASH & STRETCH PRINCIPLE
WITH JOE OESTERLE

Early animators created the "Squash & Stretch Principle." These pioneer cartoonists realized the importance of exaggeration when conveying both motion and emotion. Traditionalists would tell you your head is rigid. The skull and jawbone don't have a lot of give or flexibility to them. Luckily, you're a cartoonist. You laugh at convention, scoff at accepted truths, and—most importantly—are scared to death at the prospect of working a "real job." Notice how much emotion you're able to demonstrate by simply "rubberizing" a character's head.

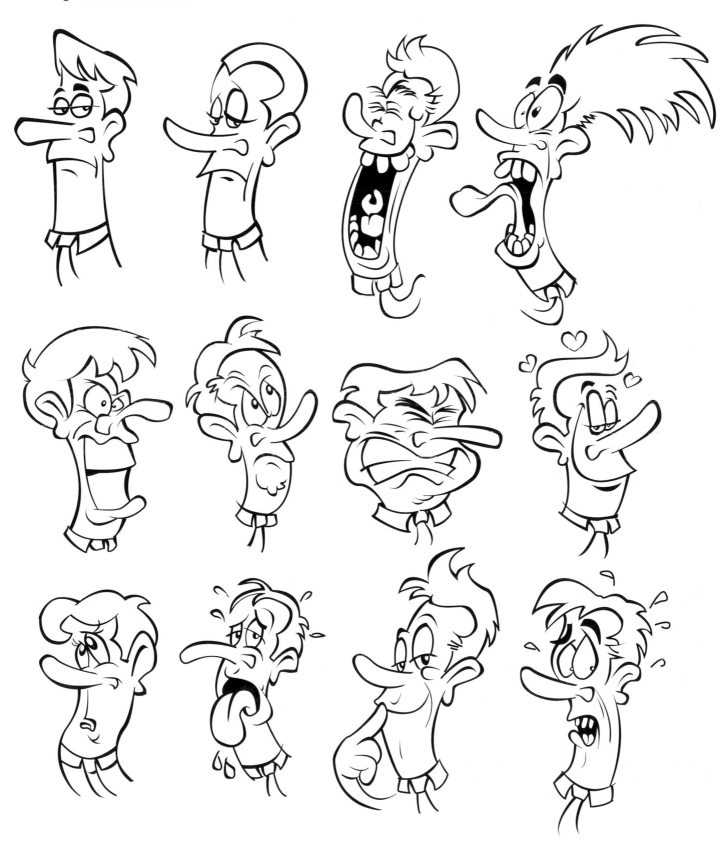

IT'S ALIVE! IT'S ALIVE! WITH CLAY BUTLER

BREATHING LIFE INTO INANIMATE OBJECTS

One of the best things about cartooning is that anything can be turned into a character—a utensil, a household item, a piece of sports equipment, a mode of transportation. Some objects, such as cars, are practically characters already and nearly ready as they are. Other objects, such as toasters, blenders, and mops, require a little creativity. But they all require three things: mobility, personality, and a means of communication.

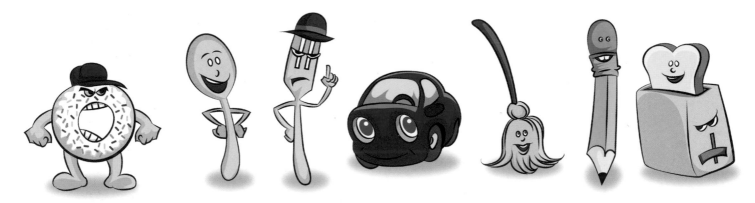

Mobility can be magical or a natural extension of the object's structure. A toaster without legs may need to magically rock back-and-forth or float to move. A ball or a tire can simply roll. Legs and hands provide an easy mobility shortcut, but they can also degrade the recognizability of the object. Eyes, eyebrows, noses, and mouths provide personality and a means of communicating

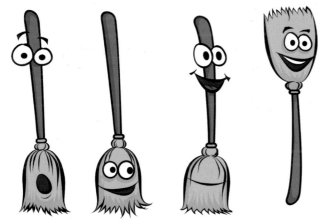

Where's my face and which side is up?

How Do I Move?

Almost all characters need to move. Some have innate abilities or structures to exploit, but some need legs and/or arms. So put yourself in the object's place. How would you move if you were a broom? Would you magically float or move by a sweeping motion? Would you bounce, shuffle, and walk on your legs? Whatever you choose, always respect the object's uniqueness—don't destroy its inherent qualities with excessive features and limbs.

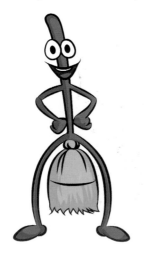

NO
Attaching the legs above the sweeper creates a bow-legged character with a large "appendage" between its legs.

NO
Attaching the legs to the bottom turns the sweeper into hips and diminishes the character's recognizability as a broom.

NO
Attaching the legs above the handle creates a character with a questionable shape between its legs.

YES
Attaching the legs to the bottom of the handle is the best choice because it retains its "broom-ness" and looks pleasant.

LEG-FREE MOBILITY SOLUTIONS FOR INANIMATE OBJECTS

Mobility as an Extension of Innate Abilities

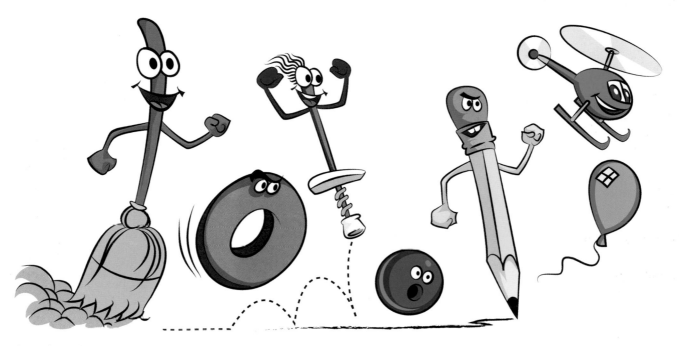

If an object floats, rolls, bounces, wobbles, or rocks, it doesn't need legs, but arms can give it a bit more personality and flexibility. Does a pogo stick need legs? Of course not! In fact, adding legs would destroy its "pogo stick-ness."

Mobility Through Magic

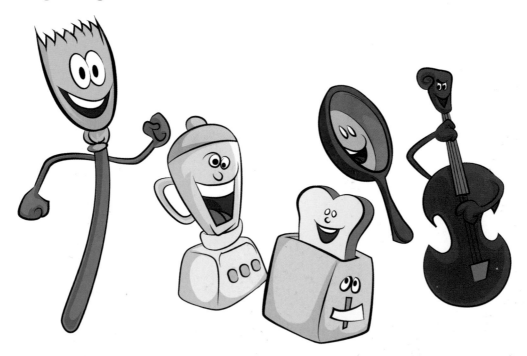

Who says legs are the only way to get around? Some objects would be so dramatically altered by the addition of legs that they need some other way to move. If they can't float, roll, bounce, wobble, or rock innately they need magical mobility. Magical ability is a catch-all for any mobility that simply can't be achieved through logical means. So can a frying pan float and wobble around on its handle. You bet!

KEEPIN' IT REAL WITH CLAY BUTLER

WHY MAKING THINGS LOOK "REAL" DOESN'T MAKE THEM FEEL MORE "REAL"

We assume that we see things how they really are—just like how a camera "sees." Replicating how a camera sees is the holy grail of most artists. The more our drawings look like a photo, the more successful we feel in capturing reality. However, we don't see reality—we see a recreation of reality using a variety of mental sleight-of-hand tricks and a mash-up of all our emotional memories. Our eyes have a blind spot, caused by the optic nerve, that the brain fills in based upon the surrounding data. There is a slight delay in what is happening, due to the time it takes to process the image our eyes capture, so our brain takes an educated guess on what will happen next and shows us that image instead. All this is combined with our expectations, emotions, and memories to form a reconstruction of what is happening in front of us. It's this subjective and emotionally-based recreation that an artist should try to capture.

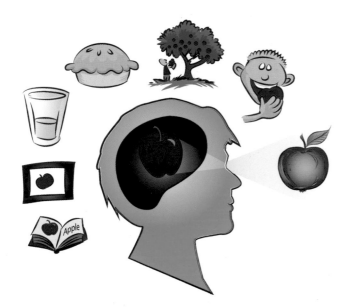

When we see an apple, our brain reconstructs an image of an apple. Every apple we've seen, tasted, or touched shapes this image. An artist's job is to tap into that reservoir of data as efficiently as possible and let the viewer's brain perform the heavy lifting of infusing meaning into your drawing.

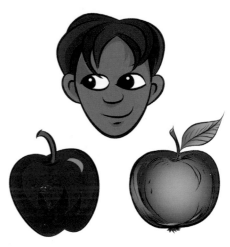

Because it allows the viewer to project a lifetime of memories into the image, a simple line drawing of a generic apple feels more "real" and relatable than a detailed drawing of a Macintosh.

THE MORE REALISTIC, THE LESS UNIVERSAL

Everyone's Grandfather ⟷ Not My Grandfather

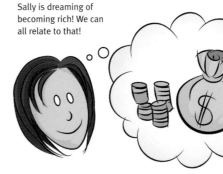

Sally is dreaming of becoming rich! We can all relate to that!

I don't drive a Toyota® Tacoma™. I don't relate.

I do drive a pickup truck. Now I get it!

 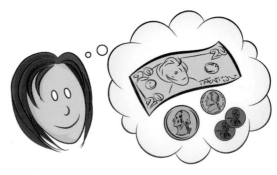

Sally is dreaming of twenty dollars and thirty-two cents! Too bad no one else shares that dream.

THE LAW OF DIMINISHING RETURNS IN CHARACTER DESIGN

The more photorealistic and specific your character, the less relatable it becomes. A cute, friendly fish becomes a nice meal with too many scales and anatomically accurate facial details. The human brain is amazingly sophisticated, so take advantage of that processing power by focusing on the simplified lines that evoke the essence of your subject. A few well-placed lines are all that is needed to tap into the viewer's skills of perception. Too much detail will create a barrier to accepting your character as an archetype. Archetypes are flexible, abstract, and universal. Photorealism is rigid, material, and specific.

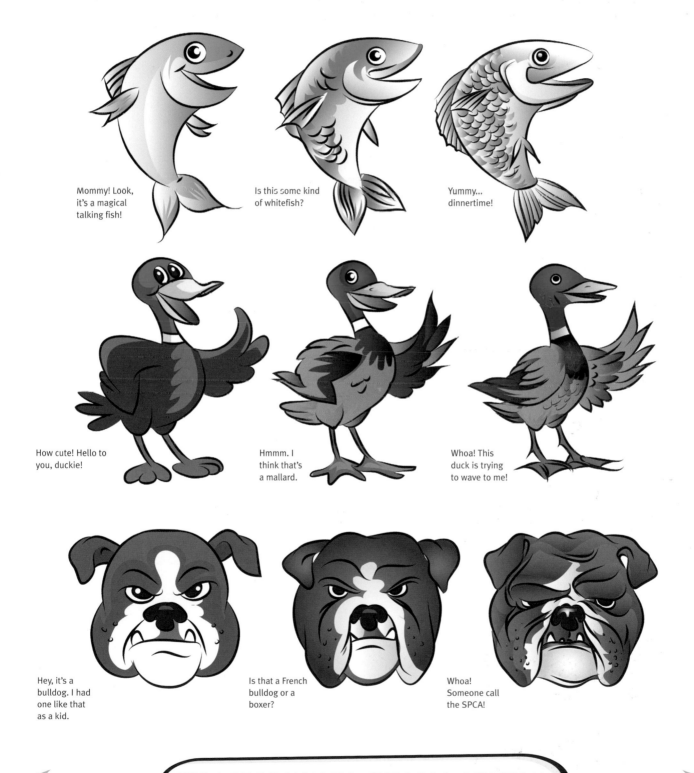

Mommy! Look, it's a magical talking fish!

Is this some kind of whitefish?

Yummy... dinnertime!

How cute! Hello to you, duckie!

Hmmm. I think that's a mallard.

Whoa! This duck is trying to wave to me!

Hey, it's a bulldog. I had one like that as a kid.

Is that a French bulldog or a boxer?

Whoa! Someone call the SPCA!

THE MORE REALISTIC, THE LESS UNIVERSAL

ANTHROPOMORPHISM WITH CLAY BUTLER

BLURRING THE LINES BETWEEN HUMAN & ANIMAL

When you draw a dog walking on its hind legs or a mouse with a cane and bolo hat, you're using *anthropomorphism*. Anthropomorphism is the attribution of human characteristics to animals—and it's probably the most widely used technique in character development.

WHEN TO USE REALISTIC ANIMALS

Most of the time there is little point in using accurate depictions of animals for your characters. By being anatomically correct they are naturally limited in mobility, dexterity, and emotional expression. However, realistic animal characters can be very powerful to illustrate irony and role reversal and to make a strong connection to nature. The classics *Charlotte's Web* and *Watership Down* are excellent examples of stories that are more powerful precisely because of minimal use of anthropomorphism.

WHEN TO USE ANTHROPOMORPHIC ANIMALS

Highly stylized and anthropomorphized animals are the default choice in animal-based character design. With their humanlike posture, anatomy, and mobility they can easily navigate our world. No need to envision a special table and chair for animals if they already walk upright on two legs. Highly anthropomorphized animals are a good choice when the story is not dependent on expressing innate animal characteristic or behavior. Bugs Bunny, Daffy Duck, and Mickey Mouse are all good examples of maximized anthropomorphism.

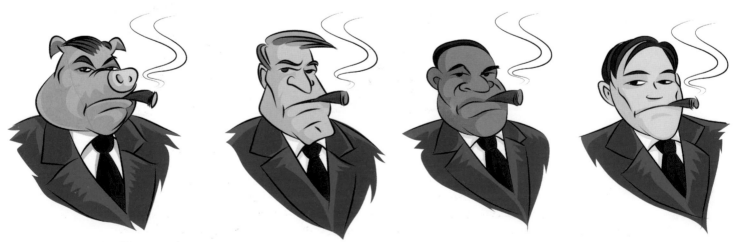

ANTHROPOMORPHISM IS UNIVERSAL

Anthropomorphism frees the artist from issues of race, gender, and ethnicity. This ruthless businessman chomping a cigar is a pig...get it? An actual pig! Hardy, har, har! Using an animal in place of a human allows us to enjoy a story at face value without the usual human baggage of power, position, and privilege. Real human characters do not exist in a social vacuum. No matter how innocent the intent or the irrelevancy to the story, readers will read meaning into the characters' race or ethnicity. A pig is free to be as ruthless as he wants and it's still just an abstraction. No one thinks it's a statement about pigs as a group. But that same character as a Caucasian, African American, or Asian man brings with it all the history, stereotypes, struggles, and aspirations of the respective group.

FROM REAL TO SURREAL

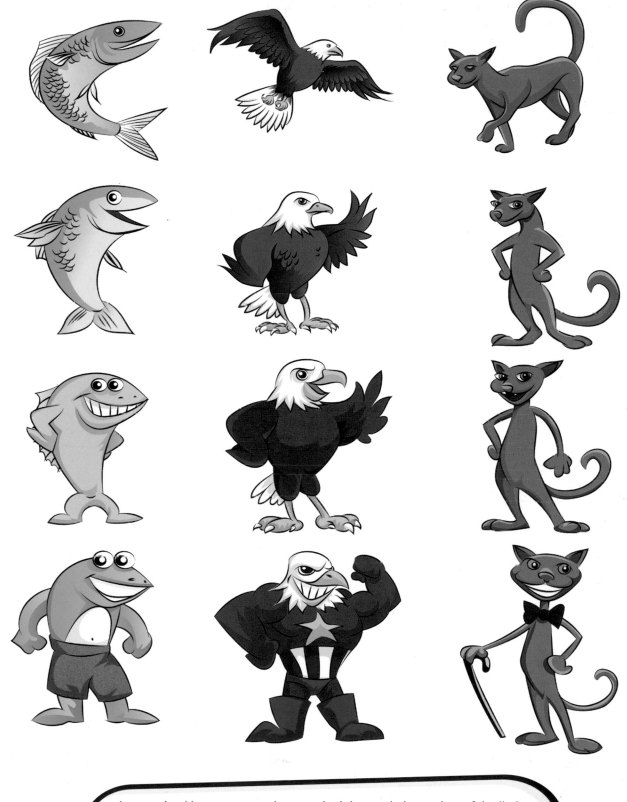

As an animal becomes more human, the joints and pivot points of the limbs change; fins and wings turn to hands; eyes move to the front of the head; clothes appear; and squared teeth replace fangs. Stylized animals are often the go-to choice for character development. However, if you want to portray the true gravity of a cat killing a mouse, a less stylized choice would have a more dramatic impact than, for example, the cartoonish hijinks of Tom and Jerry.

CARTOON APE WITH CLAY BUTLER

Like all how-to lessons, I start this ape with ovals and stick bones—even though I typically do not. Most professionals don't bother with this initial step because, through years of deliberate practice, they've internalized the anatomical rules necessary to draw anything they want. A practiced artist sees the illustration already complete in their head and starts drawing. It's sort of like tracing your imagination! If you're just beginning, build some skeletons first. If you can make good skeletons that, even in stick form ring true and are infused with life and character, the rest is easy.

STEP 1 First I draw ovals for the head, pelvis, and shoulder joints. These are the main axis and pivot points for all poses. Where you place these defines what the character is doing. Apes have broad powerful shoulders, so keep them wide.

STEP 2 Then I do the same for the legs and feet. Primates have a very long torso and arms in comparison to their legs, so shorten them up.

STEP 3 I finish with the arms and hands—the longer, the better. Remember: when primates walk, their knuckles touch the ground. You need long arms and short legs to make it work.

> GRAVITY...IT'S NOT JUST A GOOD IDEA, IT'S THE LAW!

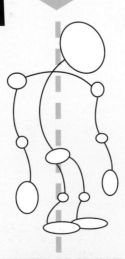

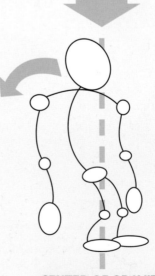

CENTER OF GRAVITY

I'm Centered

Your character's skeletal structure should be balanced over the center of gravity much in the same way the arms of a mobile are always centered below the string. This character is stable and at rest. The bones can support the character's weight easily without exerting stress on the muscles to maintain balance. Unless you want your characters to look like they are falling, always find their center.

CENTER OF GRAVITY

Help, I'm Falling!

This character's skeletal structure is off the center of gravity. The head, shoulders, spine, and hips are too far to the left, making it look like the character is about to fall backwards or, at best, getting a good ab workout!

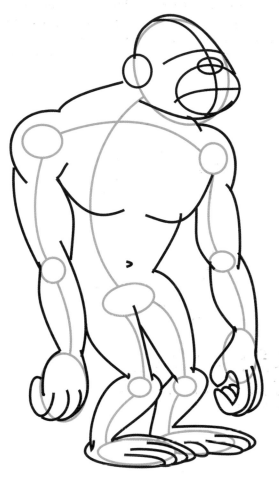

STEP 4 You can start filling in the structure anywhere, but why not start with the head? Apes have short foreheads, so keep the eye line high. If it makes things easier, draw crosshairs to divide the head into quarters. I do the same with the mouth and nose.

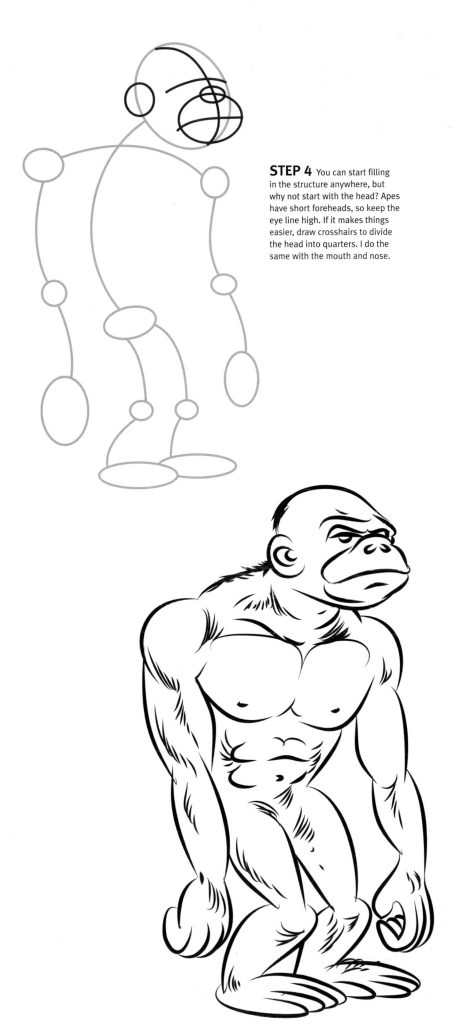

STEP 5 Now it's time to bulk up the frame and add the fingers and toes, which, for an ape, are also fingers! Some basic understanding of anatomy is a must here. You don't want to add random, meaningless bulges. If you need to, study some reference photos of actual apes.

STEP 6 I erase any guidelines I no longer need and refine my lines. I define the facial features and add strokes throughout the body to suggest muscle definition and fur. It might take some practice to learn how to add stylish muscles, but the good news is that with deliberate practice you will see HUGE advances in your abilities. So think of this as a lifelong thing—you simply need to put in the time.

CHAPTER 2

SCENES & GAGS

WITH MAURY AASENG

Once you're comfortable with character creation, you can embark on what for me is the most satisfying aspect of cartooning: setting the stage where your characters interact. Essentially I'm referring to creating the joke of a cartoon, or the "gag." In order to create an effective gag, you need a humorous concept.

In this chapter we'll explore how to create funny scenarios for our cartoon characters using common techniques such as role reversal, situational humor, understatement, and speech.

LIGHT BULB GAG

ROLE REVERSAL TWO-PANEL GAG

Often in a cartoon strip, when an idea pops into a character's mind, a light bulb appears above their head. It's a run-of-the-mill way to illustrate the concept of an idea. But in a cartoon world, inanimate objects can themselves be the characters. So I wondered: what appears above the head of a light bulb when it has a genius idea? I sketch out my concept, using shapes and fast, loose strokes to get just the basic idea down to see if my concept was as funny on paper as it was in my imagination.

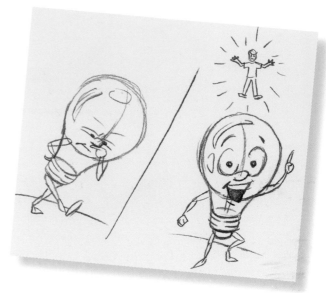

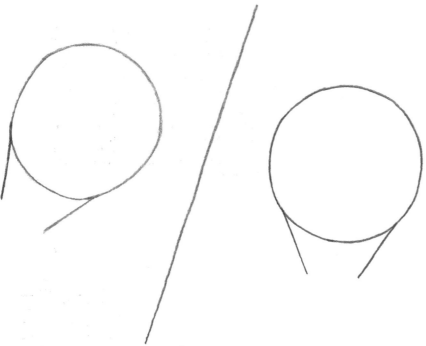

STEP 1 Deciding to move forward, I use my sketch as a basic template. Since it's a two-part cartoon, I start by dividing my paper with a diagonal slash. Then I draw a large circle on each side for the bulbous part of the light bulb. On the left side, I want the light bulb's posture bent over, because he is lost in thought. To achieve this, I draw two lines pointed toward each other, angling down from the circle and to the left. On the right side, I want the posture to be straight, so I draw two straight lines.

STEP 2 I add a curved line to connect the straight lines on both bulbs. Then I add a cup shape for the metal base with curved lines. I add simple oval shapes for the upper arms and small circles for the eyes. I make the eyes on the right bulb larger so they will appear more "lit up" as the idea hits. I draw another small cup shape at the base of each bulb. Then I continue mapping out the arms and legs with simple shapes. I draw a rounded nose under the eyes on my right bulb. On the left bulb, I place the nose closer to the eyes. Suspended mid-air above the bulb on the right I add simple shirt and pants shapes.

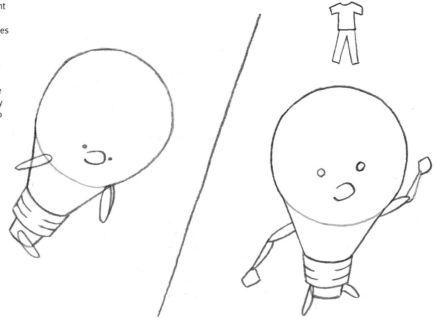

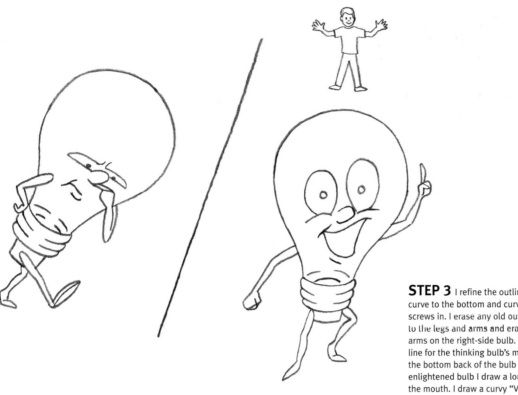

STEP 3 I refine the outline of my light bulbs and add a curve to the bottom and curved ridges to the metal part that screws in. I erase any old outlines. I finish adding shapes to the legs and arms and erase the overlapping lines in the arms on the right-side bulb. On the left, I draw a short curved line for the thinking bulb's mouth. I use very short lines at the bottom back of the bulb to suggest transparency. On the enlightened bulb I draw a longer curved line for the top of the mouth. I draw a curvy "V" shape to close up the happy mouth. I add two bulbous ovals around the pupils for eyes. Then I use little lines to draw the thumbs and cheeks. I add the head, limbs, and a very simple face and hairline to the little man above.

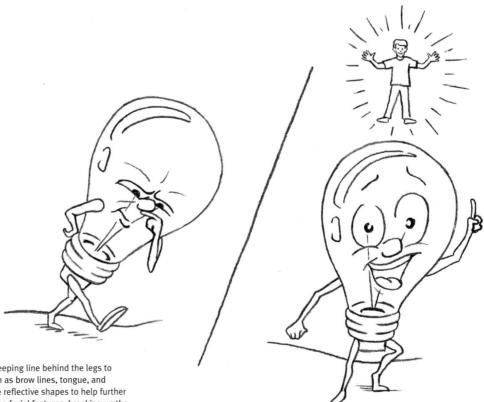

STEP 4 To finalize my pencil drawing I draw a sweeping line behind the legs to ground the light bulbs. I define the facial details, such as brow lines, tongue, and teeth to give the cartoon more depth. I also add some reflective shapes to help further suggest glass. I also add two twin filaments behind the facial features, breaking up the lines behind key facial features so as not to compete with the face. Finally I finish my "idea man" above the light bulb. I erase the oval shape behind the hair and face and add radiant dashes around the whole figure. Now it has the same glow that an "idea" light bulb would have above a human character's head.

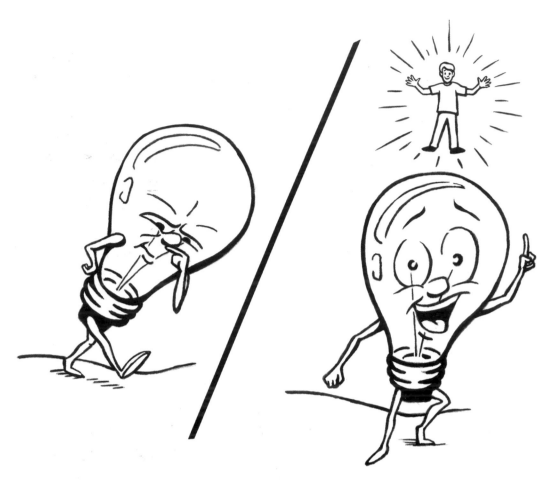

STEP 5 Time to ink! Using my brush pen, I outline the entire cartoon. I use thin strokes when creating the shadows below the feet, the facial features, reflections, and radiating glow-lines. However, I use a darker, thicker stroke to outline the actual light bulb shape. I fill in the bottom "cup" of the bulb, where it would screw into a lamp, with black. Now it looks anatomically accurate (light bulb-wise).

STEP 6 I scan my inked drawing into Photoshop and begin digitally coloring. Note that not all the shapes are entirely enclosed within lines; there are lots of open areas.

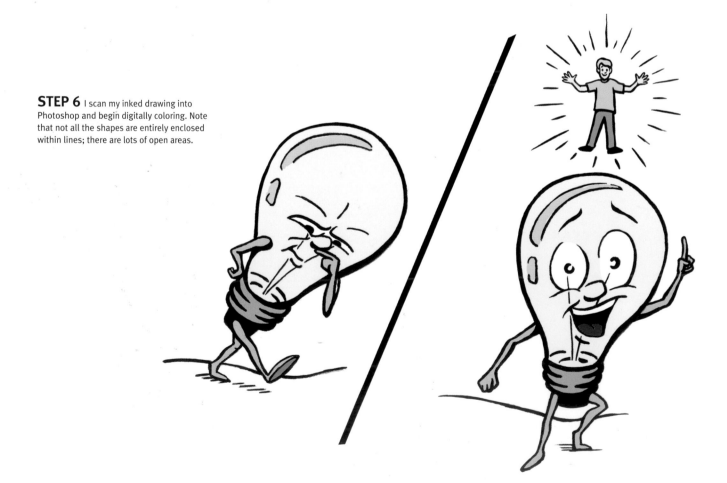

STEP 7 I finish coloring in the cartoon and then add more depth and introduce some shading elements. To highlight the inside of the bulbs I select the yellow with the magic wand tool. Then I select the eraser tool and select the size and type of eraser from the pop-up menu. I want the edges to be soft, so I pick a blurry-edged eraser shape. I use the eraser to start fading away the color. Note how the soft edges don't create a hard line, giving it a natural gradation.

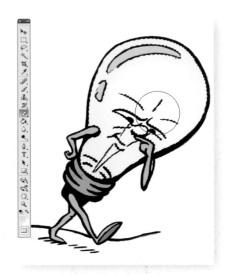

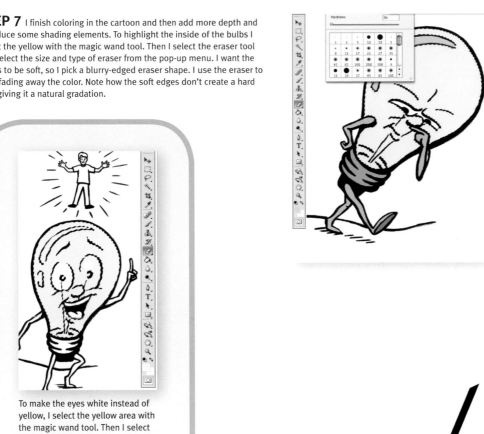

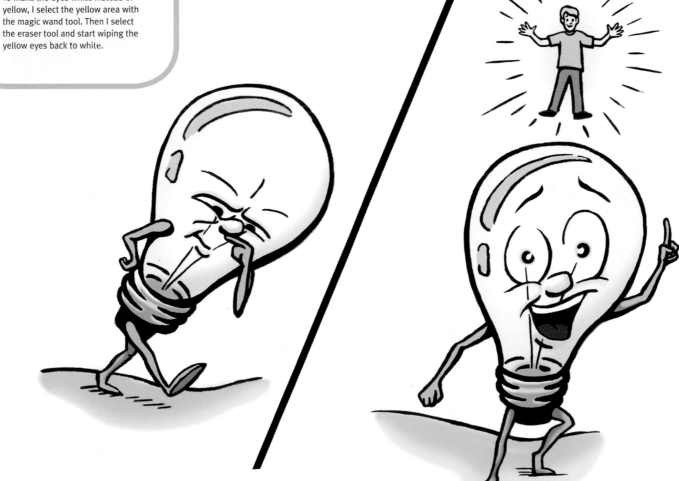

To make the eyes white instead of yellow, I select the yellow area with the magic wand tool. Then I select the eraser tool and start wiping the yellow eyes back to white.

STEP 8 I add highlights of color around the eyes, the "idea man," the ridges on the bottom of the bulbs, and the ground to create more depth. Adding some shadows will increase the effect. I select darker shades of the existing colors and add little shadows on the underside of the legs, nose and cheeks, and at the bottom of the glass bulb. Now my cartoon is finished. This hard-thinking light bulb has a shining human above his head: clearly it must be a good idea!

43

FEEDING THE PEOPLE

ROLE REVERSAL ONE-PANEL GAG

The challenge of creating a single-panel cartoon is that you have to convey more information in just a single picture. I enjoy the idea of reversing a common theme in a surprising way, like the light bulb cartoon, so I'll continue to explore that concept while paring down to a single panel.

For this cartoon, I spin the common image of feeding ducks in the park. What if the ducks were just as interested in watching people eat as we are in them? I conjure up two plucky mallards to feed the people with hot dogs. Once they start to cover the grass in front of the park bench, it's not long before folks "flock" to the food!

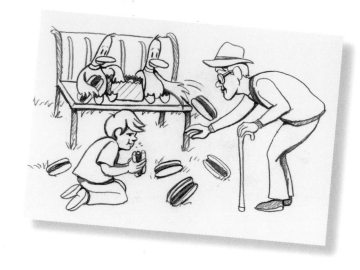

STEP 1 First I make a quick concept sketch. Though it's only one panel, there are a lot of aspects to my scene, and a quick sketch helps me map out where the characters will fit on the page. The arch of the grassy knoll mirrors the direction the duck tosses a hot dog to the man. These directional cues help spell out the joke without having to use words.

STEP 2 I draw a curved line for the edge of the lawn. Then I add a horizontal rectangle above it with a slanted rectangle that stretches from the bottom of the first. I add two large teardrops on the bench for the duck bodies. Then I begin the boy and the man by drawing simple geometric shapes to map out the heads, torsos, and limbs.

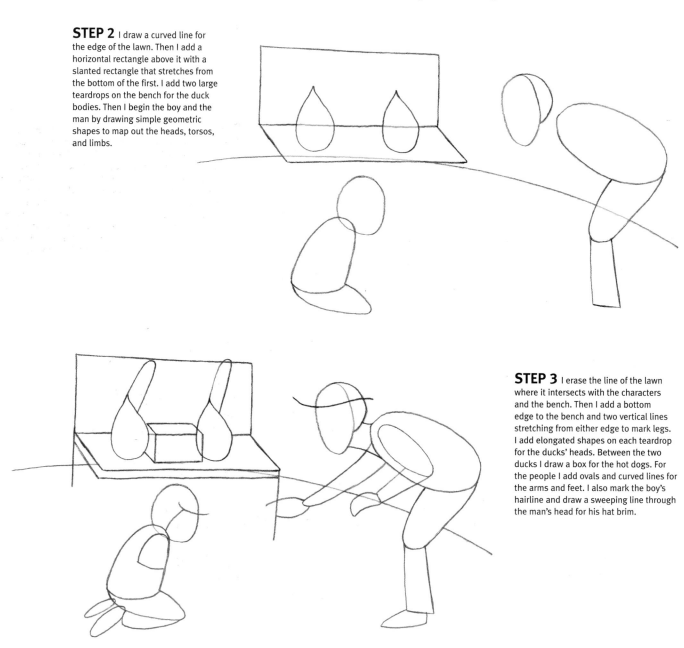

STEP 3 I erase the line of the lawn where it intersects with the characters and the bench. Then I add a bottom edge to the bench and two vertical lines stretching from either edge to mark legs. I add elongated shapes on each teardrop for the ducks' heads. Between the two ducks I draw a box for the hot dogs. For the people I add ovals and curved lines for the arms and feet. I also mark the boy's hairline and draw a sweeping line through the man's head for his hat brim.

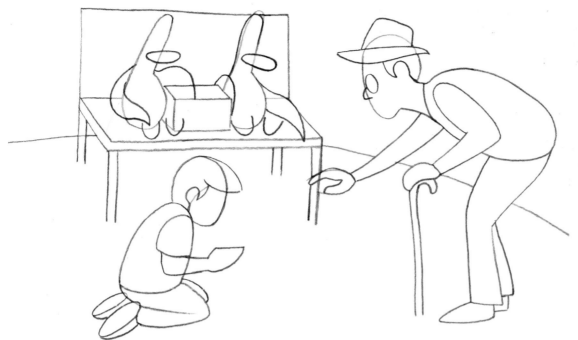

STEP 4 I continue to erase old guidelines. I add more vertical lines for the bench legs. Then I refine the head shape of the ducks and add horizontal ovals for the duckbills. I draw small "u" shapes for their feet and map out their wings with curved shapes. On the boy I cut out a shape for the ear and sideburns. I also add a line for the sole of his shoe. I draw a curved elbow and forearm with a circular wedge to block in his arm and hand. Then I finish the older gentleman's hat with a curved boxy line on top and a horizontal curve below it. I draw in a finger and thumb on the outstretched arm and the simple shape of a cane in the other hand. I also block in his nose and glasses.

STEP 5 I add curved shapes to the back of the bench to define the structure. Then I draw the eyes for the ducks and hook shapes for the bottom of their bills and toes of their feet. I also pencil in feathers on the edges of the wings. Next I start on the hot dogs. To start I draw ovals scattered on the grass for the buns. On the open buns I make a little "dip" for the crease between the top and bottom buns. I refine the boy's face by outlining the forehead, nose, puffy cheek, and chin. I also refine the hair and add a pupil for the eye. Then I refine the man's face shape and add his pupil, eyebrows, and glasses. I detail the cuffs and fringe on his sweater and a band of fabric on his hat.

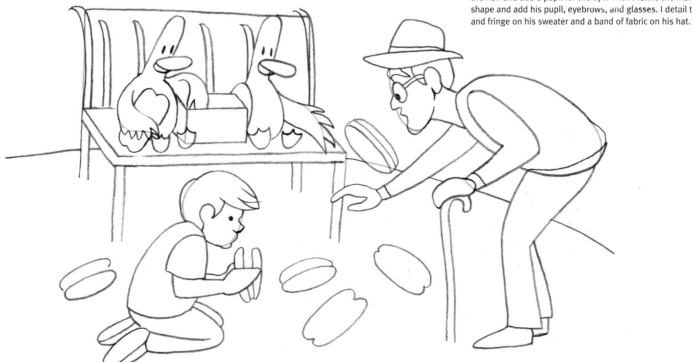

STEP 6 I erase any unnecessary lines and replace the curved line of the lawn with quick strokes for grass blades. I draw eyebrows, neck bands, and feather tufts on the ducks' heads to give them more personality. Then I add long cylinders in the buns for the hot dogs. I refine all the edges of my characters where needed, such as shoes, hairlines, and folds in clothing. I add final touches around the eyes and cheeks of the people and draw the bottom of the man's shoes and cane. Lastly I add lines on the hot dog box and dots to suggest tiny flecks of food near the boy's mouth to hint at messy eating.

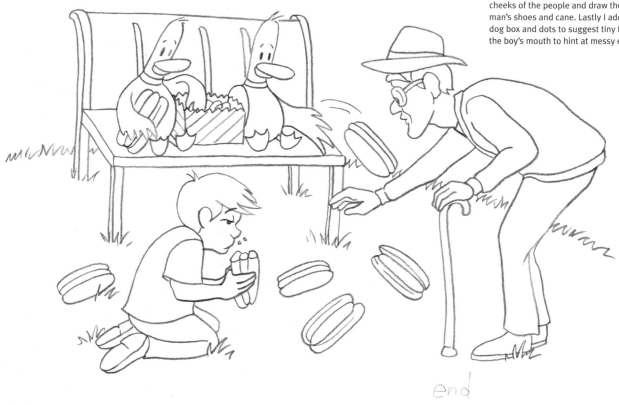

end

STEP 7 I go over my lines with a felt-tip pen to ink my cartoon. I use the most ink in areas of shadow, such as the box of hot dogs, the bench legs, and under clothing items.

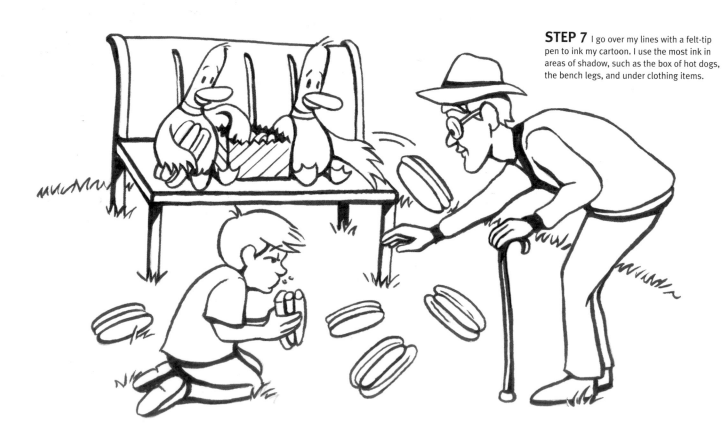

STEP 8 I scan my inked drawing and add color, one area at a time, in Photoshop. Certain colors make areas of the cartoon "pop." For example, the yellow of the boy's hair contrasts with the green grass. I used green for the ducks' heads, which picks up the color from the grass and unifies the scene. Since there is a lot happening, I use minimal shading and highlights. Placing them strategically brings life to the scene without cluttering it. I add highlights to the man's hat and sweater, the boy's head and shirt, and the ducks' heads. I add shadows to the man's head and pants, the boy's pants, the ducks' wings, and the back bottom edge of the park bench. Voila! This cartoon is complete, and the ducks are left with a lazy day in the park, feeding the various flocks of people that pass by.

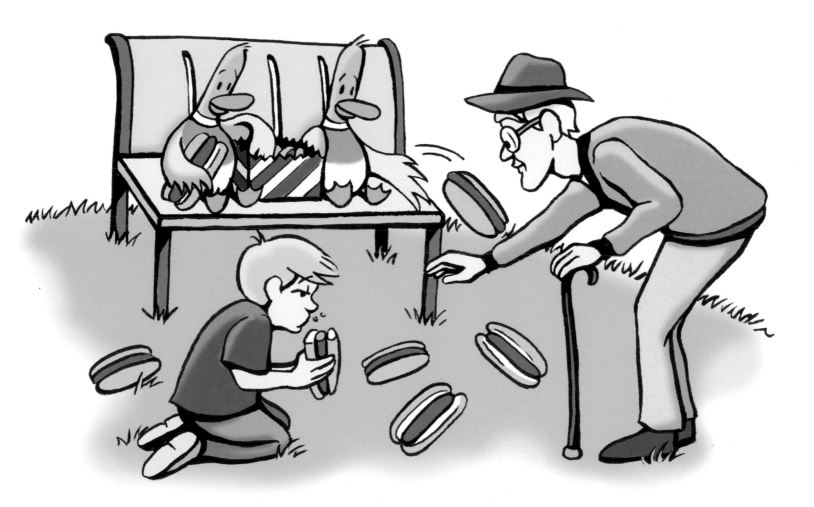

BEARS & PARK RANGER

OBLIVIOUS GAG

Another fun gag concept is to create a scene with a key character who is unaware of what is actually happening. In this cartoon, my idea is to have an unenthusiastic park ranger giving a nature talk to some school children. Bored from the repetitive presentation, she can't imagine anything interesting happening during her discussion about the wondrous acorn. She is unaware that behind her back a pair of bears is mimicking her, making her quite oblivious to what is causing such fervor in her young audience.

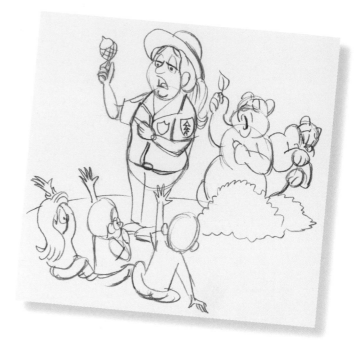

STEP 1 I start by sketching out my cartoon. I use a lot of sketchy circles to place the round shapes of the bears, the ranger, and the children's heads. I add details I think might be nice in the final illustration, such as the tree-patch on the ranger's arm and the various poses of the excited kids.

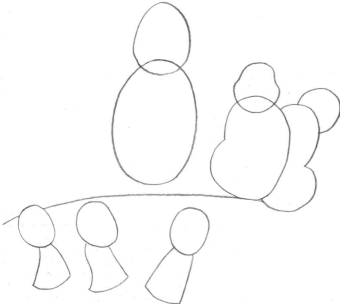

STEP 2 I start by placing my basic shapes to map the position of the ranger, the kids, and the bears. For the bears' bodies, I draw overlapping potato shapes with a fat pear shape for the front bear's head. I also mark the horizon line.

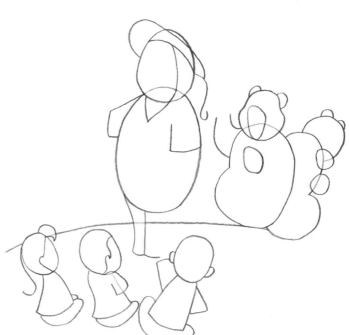

STEP 3 I begin to further define the shape of each character. On each kid I draw horizontal curved shapes for their pants and thighs. I also add some shirtsleeves and hairlines around the ears. To flesh out the ranger more, I draw a "V" for her shirt collar and a couple lines to represent sleeves and pant legs. I leave the right pant leg open for now. I also divide her head with a curved vertical line where the edge of her cheek will be and a horizontal curved line at the top where her hat fits on her head. I also add the ponytail swoop for her hair. On the foremost bear I block in the paw and muzzle and then add ears and two hooked lines for the right arm. For the back bear I draw two ovals for its paws and sketch in the ears.

STEP 4 I begin erasing unnecessary guidelines. Then I add rectangular shapes for arms and lower legs on the children. I also draw in small shapes for their hands and the noses on the two kids on the left. I add more detail to the park ranger's limbs, using basic shapes to mark the position of her arms and feet. I use a heart shape to represent her outstretched hand. Then I add the top of her hat and a hooked, curved hairline. I add buttonlike noses on the bears and connecting lines from their paws to their shoulders. Then I draw the outstretched paw of the front bear, using a mitten shape.

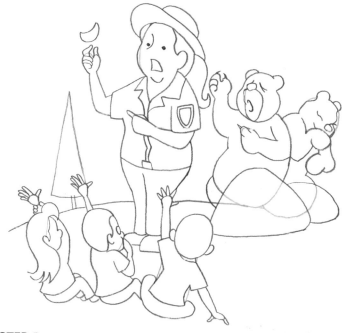

STEP 5 I erase more guidelines, draw the kids' fingers, and refine the body shapes of the boy on the right and the face of the boy in the middle. I draw an oval for the glasses lens on the middle boy. Then I draw the fingers of the ranger, refine her hairline, and add a fuller cheek. I also mark her facial features and complete the line of her pant leg. Then I add the collar, sleeve patch, and belt buckle. I draw the cap of the acorn in her hand. I add two gumdrop shapes in front of the bears to mark the bushes, and I add the leg of the foremost bear. I delineate fingers and sharp points to mark the claws on the bear's paw. I mark the eyes and adjust the shape of the muzzle and add an oval for the mouth. I complete the right arm of the bear in back and add a curved line for the mouth and an "S" shape for the eye. This is a female bear, and this shape forms an eyelash as the eye shuts. I adjust the shape of the head and then add a triangle and rectangle for the tree in the background.

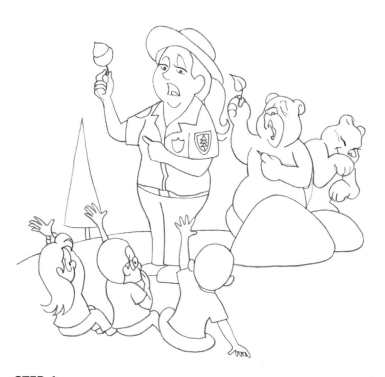

STEP 6 After erasing more guidelines I refine the right arm and hand of the boy in the middle. I also add his eye and a line leading back to his ear for the glasses. I add the eye on the girl, and then I add facial features on the ranger, including the bottom curve of the nose, a tongue, eye whites, and eyelids. Since I want her to look bored with her presentation I draw drooping eyelids that cover most of her eyes. I add detail to her badge and the tree patch, and I refine her knuckles and add the nut and stem to the acorn. Then I refine the contours of the bears' arms and paws to make them look more natural. I add details on their faces and ears and draw a basic leaf shape in the paw of the front bear. Then I finish the mouth.

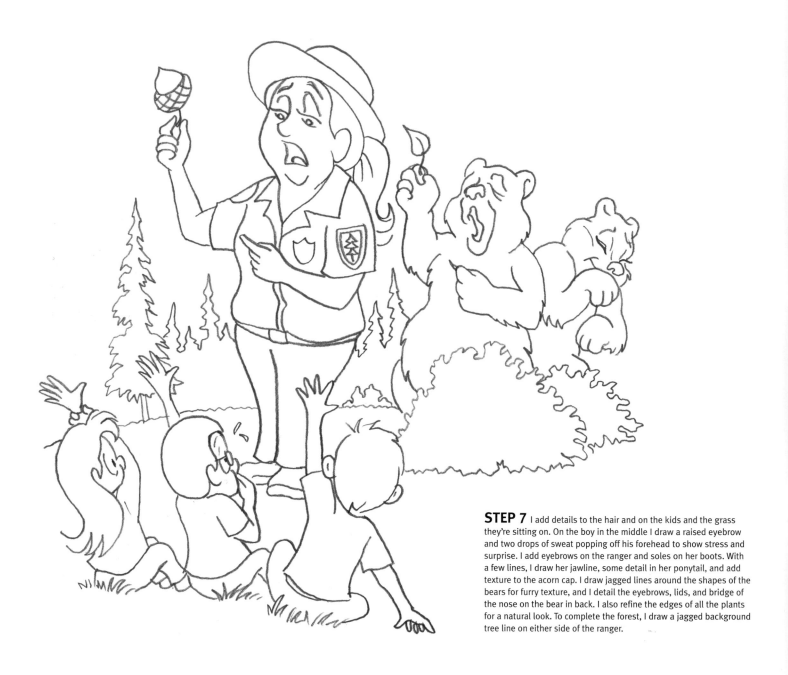

STEP 7 I add details to the hair and on the kids and the grass they're sitting on. On the boy in the middle I draw a raised eyebrow and two drops of sweat popping off his forehead to show stress and surprise. I add eyebrows on the ranger and soles on her boots. With a few lines, I draw her jawline, some detail in her ponytail, and add texture to the acorn cap. I draw jagged lines around the shapes of the bears for furry texture, and I detail the eyebrows, lids, and bridge of the nose on the bear in back. I also refine the edges of all the plants for a natural look. To complete the forest, I draw a jagged background tree line on either side of the ranger.

STEP 8 I use a felt pen to trace all my pencil lines. I color some areas more completely, like the tree trunk, the ranger's belt, and most of the middle boy's hair. Then I add shadows under legs, armpits, hairlines, and bushes. I add a pair of pine tree branches above the bears to pull a bit of the forest into the foreground. Then I scan the cartoon into my computer and begin coloring, this time using a shortcut tool. Instead of selecting each area with the magic wand tool, I use the paint-fill tool, which looks a spilled can of paint. After selecting the tool, I choose the color I want, click on any shape, and it is instantly filled with that color.

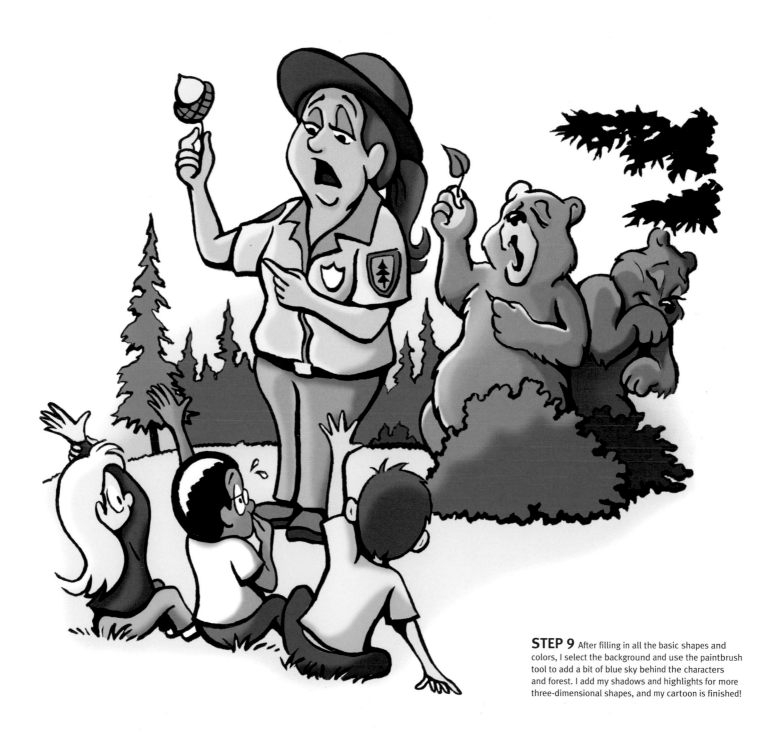

STEP 9 After filling in all the basic shapes and colors, I select the background and use the paintbrush tool to add a bit of blue sky behind the characters and forest. I add my shadows and highlights for more three-dimensional shapes, and my cartoon is finished!

IS MARS TOO FAR FOR A TOW?

SITUATIONAL HUMOR GAG

One fun way to come up with a gag concept is to just pick a character and try to invent the most comical situation you can think of in which to place them. For this comic, I play around with the idea of a tow truck driver. People might need a tow for a variety of reasons, some funny and some not so. But what if the person needing a tow wasn't typical? I decide to place the tow truck driver (Mitch) in the unlikely situation where the individual needing a tow is an alien whose space ship took a bit of a hard landing. Though, technically, a damaged vehicle is a good reason to call Mitch's Towing, he's pretty sure his little tow truck rig isn't going to make the trip to Mars.

STEP 1 I start by blocking in the scene, using very basic shapes and lines to map out the characters and their vehicles.

STEP 2 I add more details to flesh out the scene. I draw the landing gear and a large bubble for the windshield of the spaceship. I erase any unnecessary lines and refocus on the alien, drawing eyes, fingers, and more pointed tentacles. I draw a half-oval for his open mouth and a circle with two hook shapes for the hands. Then I refine the edges of Mitch's body. I define the edge of his shirt and add some detail around his head. I draw in a shape for his mustache, a hooked line to define his left arm and sleeve, and the soles of his shoes. I also refine his legs and facial features and add fingers. I render the truck by smoothing out the edges on the end of the boom and adding two more lines inside. I add half circles on the wheel for the rim and draw some lines off the bumper. I add the curved, kinked lines that follow the shape of the truck over the wheelhouse, and I define the undercarriage. I add the winch and hook off the end of the boom. I add a bumpy line over my hill and another background line behind the alien to separate the foreground and background. I also add a bush.

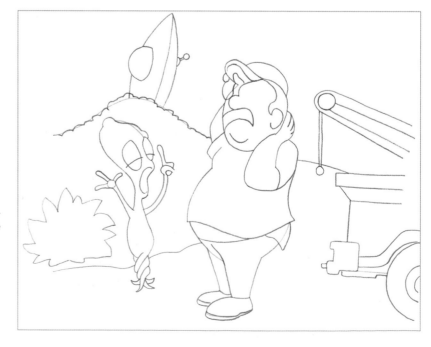

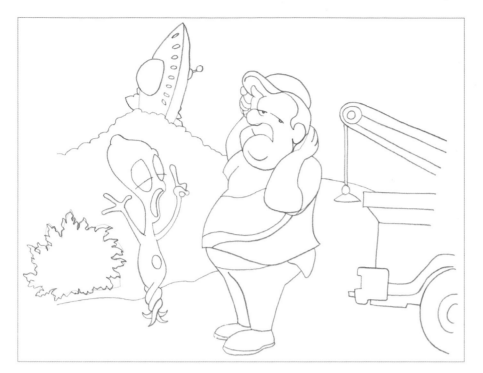

STEP 3 After erasing my guidelines from previous steps, I continue refining contour shapes. I start with the bush, adding leafy edges around the shape. Then I draw jagged contour lines from the bottom right and left of the spaceship to suggest it crumbled upon impact. I also add a series of portholes. I draw a circular belt buckle on the alien and connect the edges of his mouth. I refine the shape of Mitch's hands and add some swooping lines on his shirt where the logo will be. I add his eyes and then touch up the shape of the bottom edge of his right sleeve, the underside of his nose, his jawline, and the mustache. I add a triangular shape at the end of the truck's winch and a smaller circle in the pulley.

STEP 4 I add the rest of Mitch's facial features and refine the underside of his mustache. I add an upside-down curve for his belly button. Then I add a hook on the truck's winch, as well as some rectangular shapes in the boom. I draw a small circle above a rectangle to mark the hitch on the back. I add detail to the top of the alien's eyes to show worry. Then I draw his tongue and some curved lines for his belt. I add a hairlike line at the top of his head, and then I add branches to the bush. I draw some curvy smoke lines next to the spaceship and some irregular lines curving in from the bent-up bottom edge for a smashed appearance.

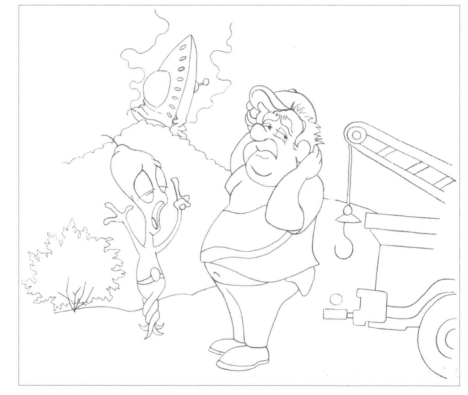

It's important to get the features just right to convey confusion and exhaustion. I add an arching line over each eye to form heavy eyelids, which suggest tiredness. I use wave-shaped lines for his eyebrows and connect the forehead to the hairline with wavy bumps to suggest a knitted brow. I use irregular, angular lines in the hair for a disheveled appearance.

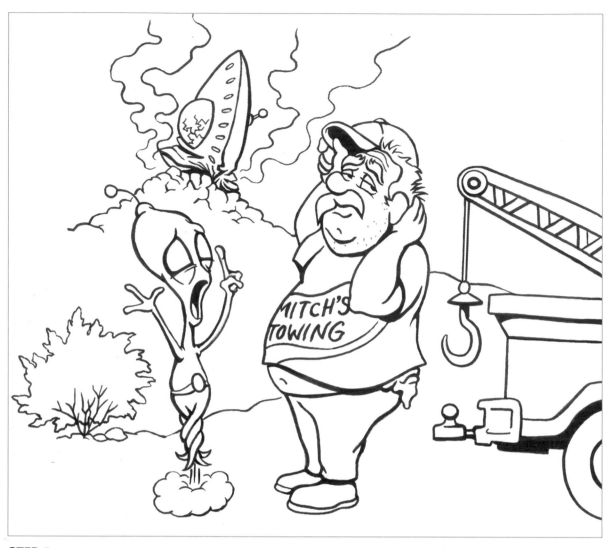

STEP 5 I add rocky edges to the hilltop, along with more crunched lines in the damaged spaceship. I also place another set of smoky lines to complete the vapor effect and add some jagged lines to crack the windshield. I add a couple rocks below the bush and a cloud under the alien to suggest he's jumping up and down in agitation. I refine his shape to give it a fleshy look around the armpits and eyelids and add a ball at the top of his head. I draw details in Mitch's cap, pant leg, and hanky. To develop his expression more I add a few curved lines on his forehead, and then I add a dimple and some dots for a 5-o'clock shadow along his jaw. Then I finish the details on the truck. I trace my drawing with a black felt-tip pen. I add extra ink in areas of deeper shadow, such as inside the alien's mouth, under the truck, the bottom of the spaceship, and under Mitch's cap.

I make the alien's eyes entirely dark, like giant pupils. I select the area inside the eyes and fill them in with black. Then I select the eraser tool and pick one that leaves a fuzzy edge. I erase out a point in each eye that will show light reflection. This also gives a cue as to where the alien is looking.

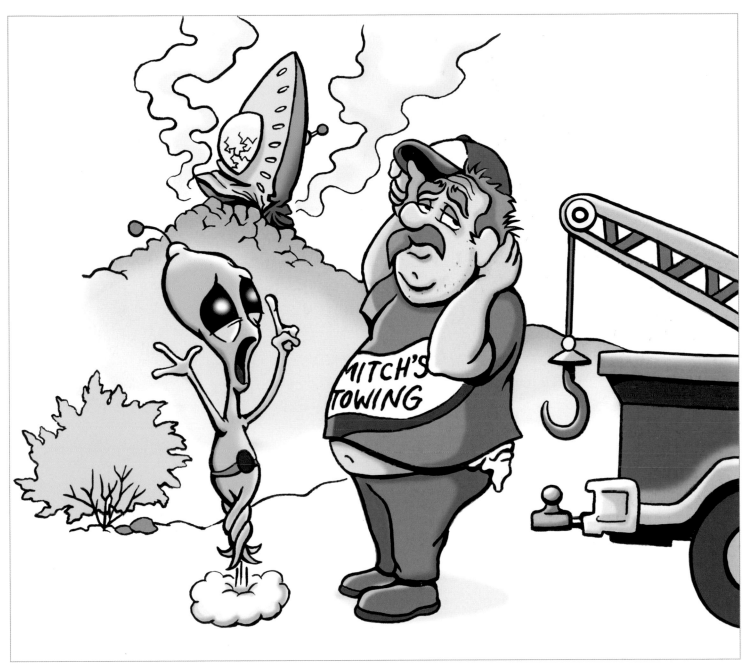

STEP 6 I scan my inked cartoon and open the file in Photoshop to color each shape individually. I choose a sandy color for the background hill and a yellow-green for the bush to give it a parched, desert look. I make sure to give the hill a sense of volume by placing darker orange at the top of the rocks. I add shading to the scene to give it dimension and add darker shadows under the spaceship, on the back of Mitch's clothing, and under his arms and the brim of his cap. I also add highlights with the eraser tool to the top of the alien's head and hands, the spaceship's windshield, Mitch's shirt and shoes, and all around the truck. I also add a little bit of gray to the inside of the billowing smoke.

GRANNY MAKES COOKIES

THE CLASSIC UNDERSTATEMENT

By introducing dialogue into a comic gag, you can expand the humor beyond just visual. Here I create a comic with a line spoken by the character, and I decide to explore what might be an amusing understatement. I grew up in the upper Midwest, where understating things is often the norm. My grandma was a champion at understatement! On a camping trip, a giant fireball erupted from the stove and melted an entire wall of the tent she was in. She simply commented quietly, "My heavenly stars." So, with this spirit, I decide to see how wrong I can make a simple baking task turn out, and then add an understatement spoken by the baker to sum it up.

STEP 1 I draw my initial lines to block in the oven, granny, and the cookbook. You can use a ruler to get perfectly straight lines for the oven and cookie sheet.

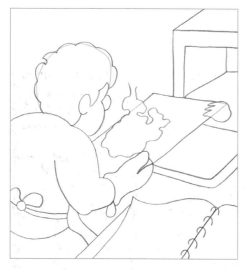

STEP 2 I add arches down the cookbook spine to create the ringed binding. Then I refine the shape of the oven mitt and add the bow to her apron. I follow the outer edge of her initial hairline and add bumps to suggest big, wavy curls. I map in an organic shape for the disastrous cookies and a blob hanging off the edge of the cookie sheet with little fingers. I draw more lines on the oven door and inside the oven to make it three-dimensional.

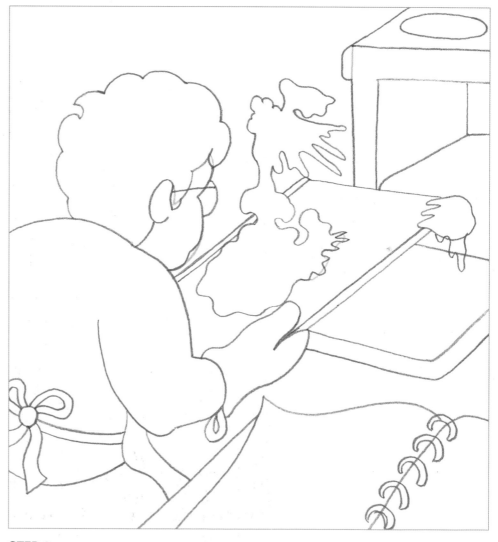

STEP 3 I erase my guidelines from the previous step and continue working on the mess of cookies. I extend the big cookie shape up into an exploding fan shape. I leave it bumpy on the left so it looks like it's bubbling. I make the right side more fingerlike. On the small cookie blob I add a dripping shape hanging off the bottom. Now it's really starting to look like a recipe gone wrong! I finish the apron knot and add a loop on the oven mitt. I add a burner on the top corner of the oven. Then I finish the spirals on the cookbook and refine the hairline around the ear and bangs. I draw a line from the glasses lens to the ear.

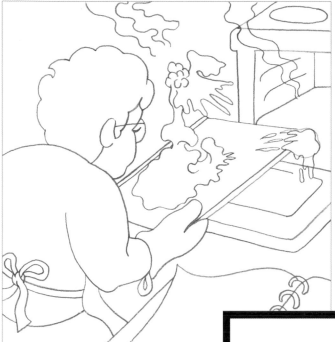

STEP 4 I erase any unnecessary lines. I rework the apron knot to look more natural. Then I add an eyelash extending toward the glasses lens. I add two lines on the cookie sheet to form ridges. I also add two parallel lines inside the oven where the cookie sheet might slide in. In the open oven door I add a window. Next I work on the ruined cookies. I give the small blob a bumpier edge. On the larger mass, I draw circular bumps in the top left to look like bubbles. Then I extend some of the curvy contour lines into the mass to help give it shape and definition. I add wavy smoke lines coming from the bubbling cookie dough and the oven.

STEP 5 I erase any lingering guidelines and finalize all my details. I add more definition to the hair and a curved line behind her neck for the top strap of the apron. I add diagonal lines in the oven window to suggest glass. Then I focus on the cookie clumps. I add small oblong shapes for melted chocolate chips and splats of cookie spraying out from the main clump. I add dots of cookie dough falling onto the oven door and a flame coming from the top. Then I add text for the cookie dough recipe and the caption. Next I ink the illustration, using a variety of line thicknesses and creating lots of light and dark areas. I color in granny's skirt, as well as the topmost ridge on the cookie sheet. I use thick lines at the opening of the oven door, under her elbow, behind her hairline, behind the oven mitt, and in the cookie sheet's shadow on the oven door. These dark spots help the lighter areas pop out, which adds a sense of dimensionality.

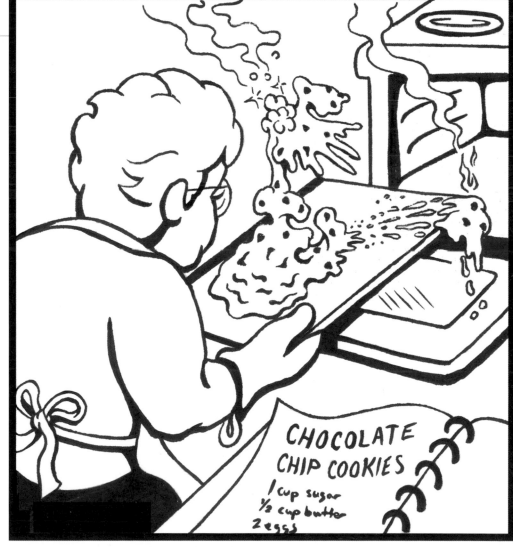

"Oh...my. These really aren't coming out quite right..."

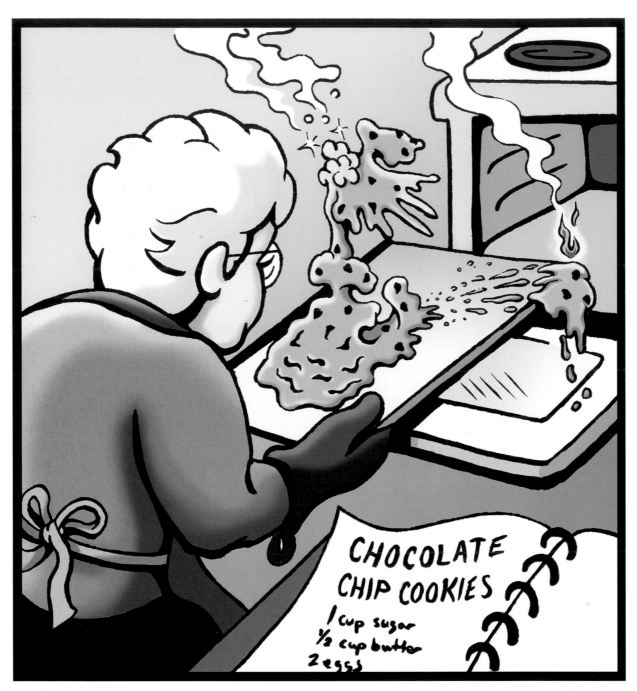

STEP 6 I scan my inked cartoon and color it in Photoshop, starting with simple color in each shape. I choose four main colors—pinks/maroons, browns, grays, white, and green—so that the focus of the gag isn't drowned out by a cacophony of color. I add a gradient to the background (see page 59). Then I complete my cartoon by adding highlights and shadows. I highlight the top edge of the cookie mess with yellow, giving it a golden, "baked" look. I use a soft-edged eraser to highlight the area around the little flame, the top of the woman's shirt, her apron strap, and the oven mitt. I add just a few shadows under her arm, waist, on the right side of her hair, and along the right and bottom edges of the cookie mess. I also apply a gradient in the oven window and on the cookie sheet. Now the cartoon is complete, and this sweet old lady is free to figure out what went wrong. Maybe next time she'll use more brown sugar and less gunpowder?

CREATING A
BACKGROUND
GRADIENT

I select the entire background with the magic wand tool. Then I pick the initial background color, as well as a darker shade of green, in my color palette at the bottom of the toolbar.

With the background selected I click on the gradient tool. I click on the left top corner of the background and, holding the mouse down, drag the gradient line down to the right corner.

I release the mouse button and now have a seamless gradient running from the top left (light green) to the bottom right (dark green).

THE POPE, A NINJA & A COWBOY WALK INTO A BAR

SPEECH BALLOON CARTOON

Anyone who reads the Sunday comics sees the most common type of cartoon strips, which employ speech balloons. The balloon appears above the head of the character speaking, and the dialogue is usually the focus of the gag, with the drawn cartoon reinforcing the humor. It's a fun challenge to create a comic that requires both the speech balloon and the illustration in order for the humor to work. My concept is for someone to read the caption, look at the image, take a moment, and then get the joke! In this case, a speaker emphasizes the need for someone to say the punch line of the joke. It doesn't make sense until you look at the cast of characters and realize that the pope, a ninja, and a cowboy have walked up to a bar—and the joke mentioned is the one in which they all exist.

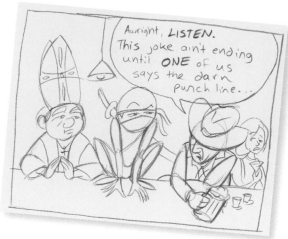

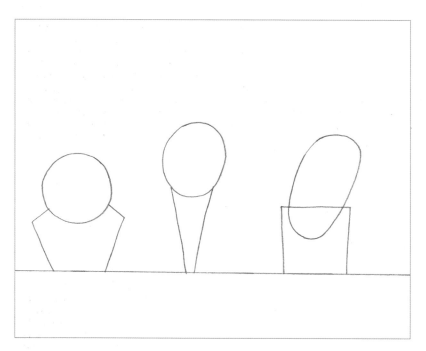

STEP 1 I begin by drawing a rectangle for my cartoon panel. About four-fifths of the way down, I draw a horizontal line for the bar. Then I use simple shapes to map out my characters: a circle overlapping a kite shape for the pope, an oval on a wedge for the ninja, and a square with a stretched oval for the cowboy.

STEP 2 I add the pope's hat and a curved line stretching from the shoulder to the edge of the panel and a set of two curved lines for the hands in the middle of the body. I work on the ninja from the inside out, starting with two curved lines in his head where his face will peek out. I draw two cane shapes stretching from each side of the head and then two boomerang shapes for the legs. I draw the exterior of the cowboy's hat around his oval head. Then I draw curved lines for his shoulders and mark the arms.

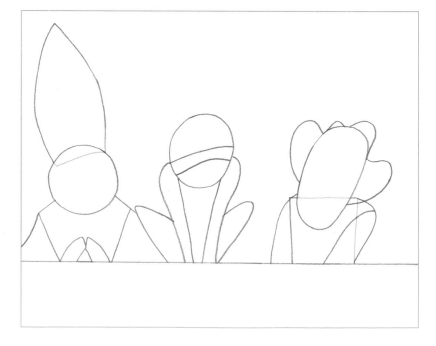

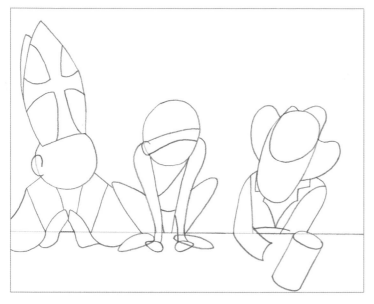

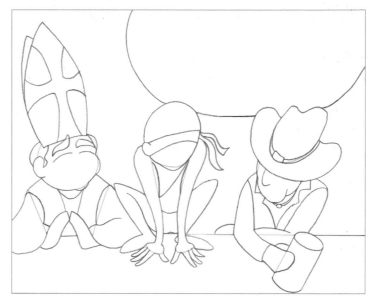

STEP 3 I erase guidelines from my previous steps and work on adding detail from right to left. I draw a tilted egg shape in the middle of the cowboy's hat to mark the inner edge of the brim. I add the shirt collar and extend his right arm down and onto the bar, and I map in the mug in his hand. I add a "C" shape for the ninja's ear, a diagonal line across his chest, and a curved line between his arms to mark his pants. I draw shapes for his feet and hands. I add a curved cross in the pope's hat and the back part of the hat just peeking out to the left. I draw a large "C" for his ear and complete his sleeves. Then I add the palms of his hands and two lines from his head to his fingers.

STEP 4 I refine the pope's form, drawing a new contour line around his head, marking the edge of his cheek, chin, and hairline. I add two eyebrows and arches for his eyelids. I draw a "scoop" below his chin to mark his necklace. Then I redraw the inside edges of his sleeves with the natural looking curved lines of his robe. I add two tails on the side of the ninja's head. Then I modify his chin, making it more angular. I refine the legs and add his fingers. I erase the top of the oval I drew in the cowboy's hat and add a second line just outside the bottom of the oval, with a square buckle in the center. I finish the outside brim. I define his chin and jaw on the bottom right. I extend the left cheekbone out a bit and add the hooked nose. Below his neck I add another line with a circle in the middle for the knot of his bola tie. I finish the arms and add a thumb on the hand. Then I add my speech bubble, stretching two-thirds across the top panel edge.

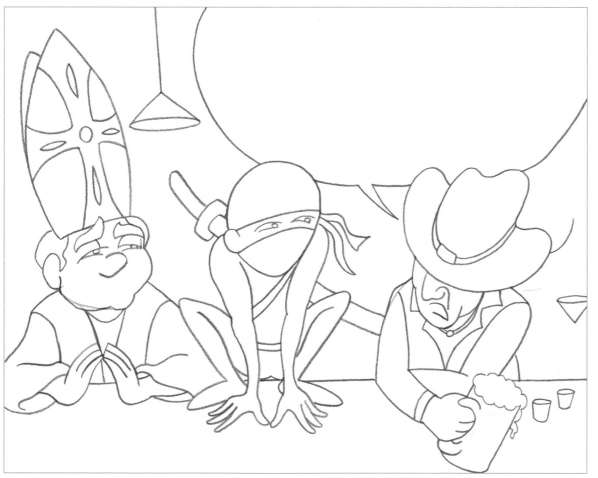

STEP 5 I erase any extra lines. I refine the cowboy's facial features and add a mouth, his shirt cuff, some lines to mark his fingers, and the mug's handle. I go around the top of the mug to add cloudlike bumps for foam, as well as a little spilling out of the glass. I also add two shot glasses. I draw a triangle for the speech bubble. I add more lines to the ninja for his belt and katana (sword) strap, and I draw in the sword behind his right shoulder and extending behind his knee and the cowboy. I add the ninja's eyelids and two little circles for pupils. I add some decoration to the pope's hat and curved lines to mark his fingers. I add facial features and wavy lines at the edge of his sleeves to mark the cuffs. I connect his hands to the inside cuffs and round out the edge of his face. Then I draw a simple lamp hanging down.

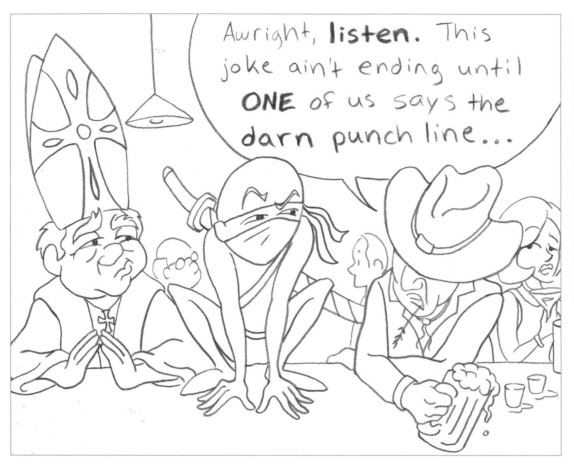

STEP 6 I draw in the pope's mouth and a little cross on his necklace. I add a few detail lines to his robe and some lines on his face for a fleshier appearance. Then I add detail to the ninja's sword with some curved lines. I draw two suspicious eyebrows on the ninja: one arched and one like a sideways "S." I thicken the ninja's eyebrows and add some fabric lines on his mask. I add a couple lines in the top of the cowboy's hat to give it some form and another pair of wavy lines for the ends of the bola tie. I draw a piece of straw in the cowboy's mouth and finish his hand. I refine the outer edge of his hands and sleeves and add a couple of spill rings under the shot glasses. To make the location obvious, I add background details and people to give it a bar atmosphere. Don't add too much detail in the background. You don't want to detract attention from the three main characters!

STEP 7 I trace the cartoon in ink, making the lines around the three main characters thicker than those on the background people. Since the ninja's outfit will be dark, I make his outline particularly thick all the way around. I add some dark shading on the cowboy's head to suggest shadow from his hat. I use thinner lines to ink the areas that I don't want to be too dark, such as the pope's eyebrows and hair, the top of the cowboy hat, and the foam in the cup.

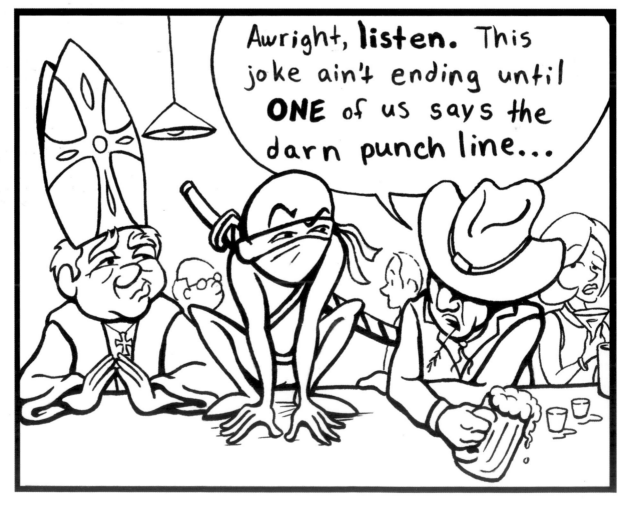

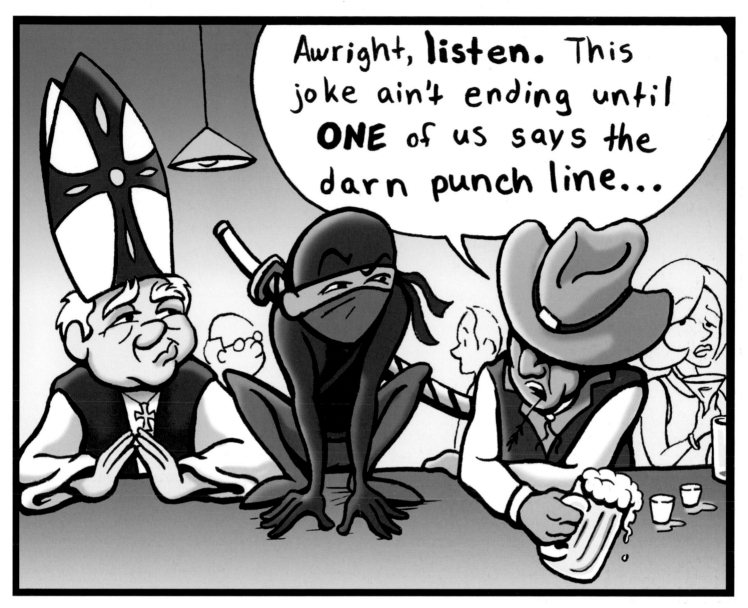

STEP 8 I scan my inked drawing and color the cartoon. I color the entire background, people and all, a light shade of blue. This helps direct the focus on the three main characters by separating the foreground from the background. I add a gradient to the background to light the bar more dimly and create ambience. To finish, I add highlights and shadows. I make sure to add highlights on the edges of the clothing that face the lamp. I also add a gradient effect to the bar, and then I'm finished! The gag has been set up: The Pope, a ninja, and a cowboy walk into a bar...but as the impatient cowboy points out, this joke isn't going anywhere without some doggone follow up!

CHAPTER 3

LETTERING

WITH JIM CAMPBELL

Lettering is arguably the most underrated and misunderstood aspect of creating a cartoon or comic. Comics are a storytelling marriage of words and pictures, making the crafting of speech balloons, captions, and sound effects that marry the writer's words to the artist's pictures as important as the art itself. Often, however, the lettering is treated as an afterthought.

Good lettering will elevate the overall standard of your comic pages, improve the experience of your readers, and benefit the telling of the story in subtle but important ways.

For most of the comic book medium's history, lettering was done by hand and has only moved to exclusively computer-based techniques in the last 10 years. With this change, the field has ceased to be one of calligraphy and become one of typography. Although different from calligraphy, typography is a graceful and rewarding discipline deserving of close attention and careful study.

In this chapter we'll take a quick look at hand lettering, study how to format text, and learn how to create different types of speech balloons and sound effects.

HAND LETTERING

Very few letterers still work by hand; the practice is most common now with creators who both write and draw their own work. But even letterers working digitally can learn much from a little time spent hand lettering. If you want to experiment with hand lettering, you will need the items below, available from any good art supply store.

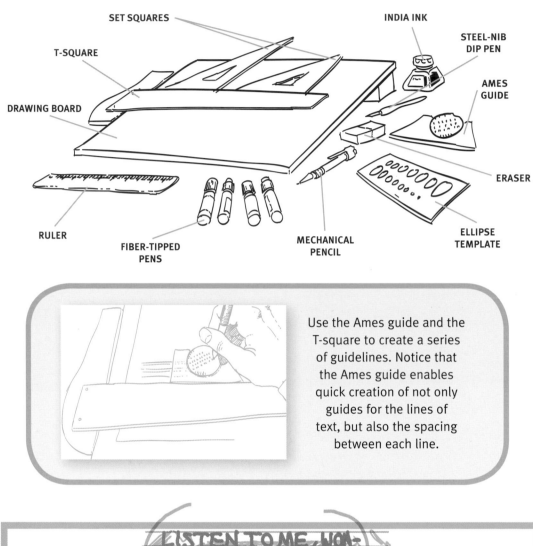

Use the Ames guide and the T-square to create a series of guidelines. Notice that the Ames guide enables quick creation of not only guides for the lines of text, but also the spacing between each line.

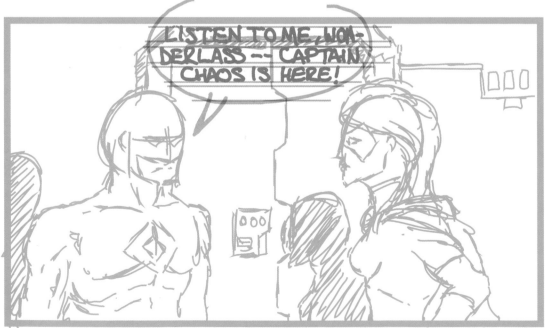

STEP 1 Let's add a speech balloon to this penciled panel of art. After drawing the rough balloon and guides in pencil, I add words. Don't be afraid to erase and re-write until you have a block of text that looks attractive. If you find that lines of text don't comfortably fit the space, rub them out and try again. Avoid breaking words with hyphens and—under no circumstances—simply squash them or make them smaller to make them fit!

SSSSS

Some calligraphic pens have a slightly angled nib to vary the width of the pen stroke. Many letterers used to create a custom stroke by gently filing one edge of the nib of a standard drawing pen with fine sandpaper. Note that this will take a lot of practice, and you will probably go through many nibs looking for a result you like!

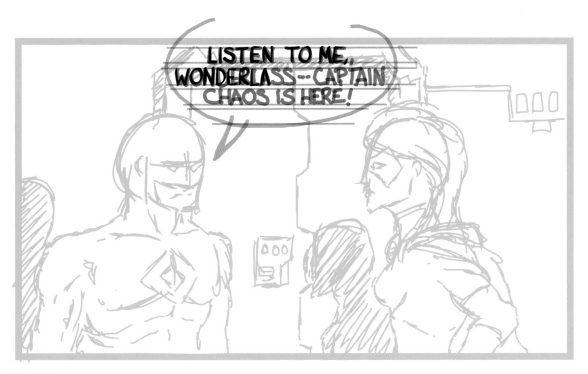

STEP 2 When I'm happy with how the text fits the balloon, I take my dip pen and ink and start to neatly render the letters in black ink.

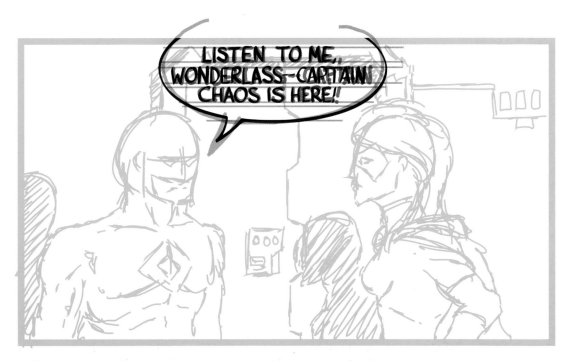

STEP 3 I use an ellipse template and fiber-tipped pens to draw the balloon, leaving a small gap for the balloon's tail. I draw the tail by hand. When all the lettering is complete on a page, the art is ready for inking.

FORMATTING TEXT

All lettering starts with artwork and a script. Even if you're writing, drawing, and lettering a story yourself, I recommend writing your dialogue as a script so you have the benefit of a spell-checker if you use a word processor.

Page One

Panel 1
Medium shot. Captain Chaos and Wonderlass run into each other in the corridor outside Dr. Dread's laboratory. The lab door is closed.

Capt Chaos: Listen to me, Wonderlass—Captain Chaos is here!

Panel 2
Close-up. Capt Chaos snarls as he gets ready to blast his way through the door.

Capt Chaos: Dread thinks he can hide away in his lab…

The script should be in a word processing document—any word processor is fine. It's helpful to have your script in electronic format because comics have some unique formatting. It's much faster to make your formatting changes in an electronic document than to try and remember to do so as you letter the comic pages. This part of the process isn't very exciting, but it's necessary and quick to do.

We'll discuss fonts in detail a little later, but in most comic lettering fonts the uppercase and lowercase letters appear as subtly different versions of each other. We can see how many lettering fonts work by converting text in a normal typeface into a comic-lettering font. Here I've converted Times New Roman into Comicraft's CCJoeKubert.

LeTtEring
LETTERING

Notice how subtly different versions of the letters "T" and "E" are produced by typing a lowercase letter and an uppercase letter.

uNnEcesSary
UNNECESSARY

Close inspection reveals that the lowercase and uppercase letters "N' and "S" produce slightly different characters.

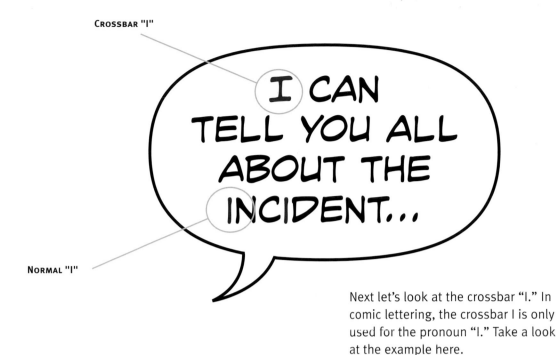

CROSSBAR "I"

NORMAL "I"

Next let's look at the crossbar "I." In comic lettering, the crossbar I is only used for the pronoun "I." Take a look at the example here.

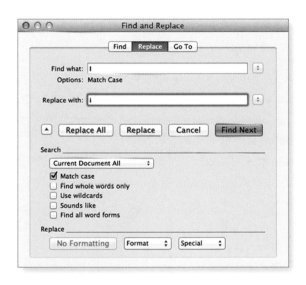

You can use the Find/Replace function in your word processor to make sure that the correct versions of the letter are used. Simply activate the Find/Replace function and make sure "Match Case" is selected. Search for "I" (capital) and replace with "i" (lowercase). Click "Replace All."

Repeat the process and search for "i" (lowercase), followed by a space. Replace with "I" (capital) followed by a space. Click "Replace All." Then search for "i" (lowercase), followed by an apostrophe. Replace with "I" (capital), followed by an apostrophe. Click "Replace All."

Most of your "I" and "i" letters will be correct after this, but keep an eye open for words like "taxi," which will now have a capital "I" at the end.

Many scripts have double spaces after each period in a sentence. You don't need these and can change this using Find/Replace as well. First type in two spaces in "Search." Type one space in "Replace" and click "Replace All."

Now that you've done all your preparation, you're ready to get started on lettering in earnest!

BALLOONS & CAPTIONS

Lettering digitally can be done using a variety of software packages (such as Photoshop, CorelDRAW®, InDesign®, and QuarkXpress®), but the majority of lettering is done using Adobe Illustrator®. The following techniques concentrate on that software package; however, the basic principles described and the drawing tools used will apply in any of the applications mentioned.

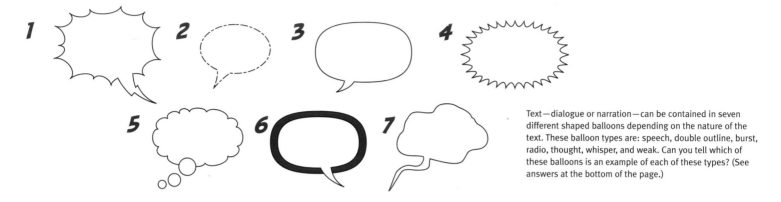

Text—dialogue or narration—can be contained in seven different shaped balloons depending on the nature of the text. These balloon types are: speech, double outline, burst, radio, thought, whisper, and weak. Can you tell which of these balloons is an example of each of these types? (See answers at the bottom of the page.)

BEZIERS, HANDLES & ANCHOR POINTS

Before we dive into each balloon, let's cover a couple of basic concepts that will help you use the drawing tools in Illustrator—or any software package that works in a similar manner.

When you create a shape, that shape has a number of "anchor points" that help define how it looks and behaves.

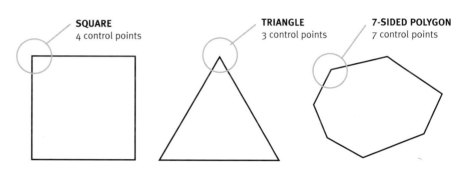

SQUARE
4 control points

TRIANGLE
3 control points

7-SIDED POLYGON
7 control points

SELECTION TOOL
In Illustrator, you can move or scale the objects with the selection tool.

DIRECT SELECTION TOOL
Or you can manipulate the individual control points with the direct selection tool.

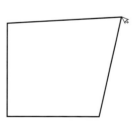

Curves are defined with Bezier anchor points, which you can recognize by their "handles."

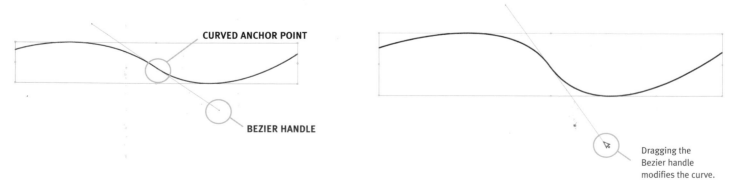

CURVED ANCHOR POINT

BEZIER HANDLE

Dragging the Bezier handle modifies the curve.

PEN TOOL

You can create your own Bezier curves using the pen tool. Simply click on your document to create the starting point of your curve. Then click to create a second point. If you click and release the mouse button the pen draws a straight line between the two points. However, if you click, hold down the button, and drag the mouse, your anchor point gains Bezier curves. As you drag the mouse the line becomes more curved. The beauty of Bezier handles is that you don't have to get the curve exactly right as you draw it—you can always go back and adjust it using the handles.

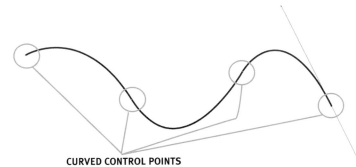

CURVED CONTROL POINTS

It's important to note that sections of a Bezier curve will influence each other to create a naturally flowing stroke. Try using the pen tool to create a curved line; then click again a little distance away from the end point of your curve.

This is fine when you want to make a smooth curve, but what if you want the direction of the line to change sharply, such as when you create the point at the tail of a balloon?

If you don't want the next part of a curved line to be affected by the previous one, simply move the pen tool over the point you've just created and the tool icon will change slightly.

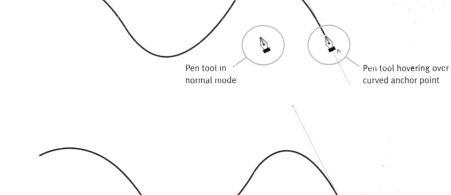

Pen tool in normal mode

Pen tool hovering over curved anchor point

When the tool icon changes, click on the anchor point, and one half of the Bezier handle will disappear.

This means that the curve you just created will remain unchanged, but the new section of the line you're drawing can be straight or curved in any direction you choose without being affected by the curve you've just drawn. It may sound complicated, but it's a concept that becomes clear very quickly with a little practice!

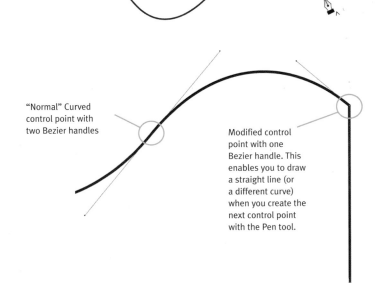

"Normal" Curved control point with two Bezier handles

Modified control point with one Bezier handle. This enables you to draw a straight line (or a different curve) when you create the next control point with the Pen tool.

SPEECH BALLOONS

For most comics, the majority of balloons are normal speech balloons. Luckily, these are the easiest kind of balloons to create! Start with a circle or an ellipse.

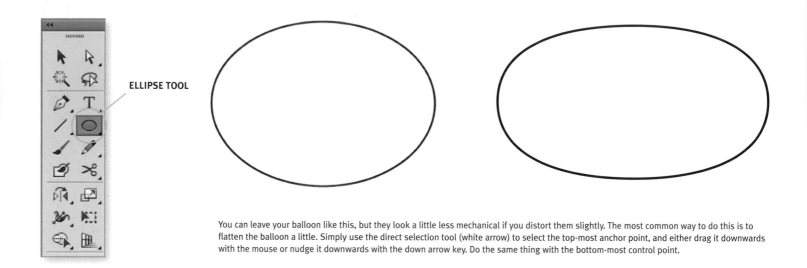

ELLIPSE TOOL

You can leave your balloon like this, but they look a little less mechanical if you distort them slightly. The most common way to do this is to flatten the balloon a little. Simply use the direct selection tool (white arrow) to select the top-most anchor point, and either drag it downwards with the mouse or nudge it downwards with the down arrow key. Do the same thing with the bottom-most control point.

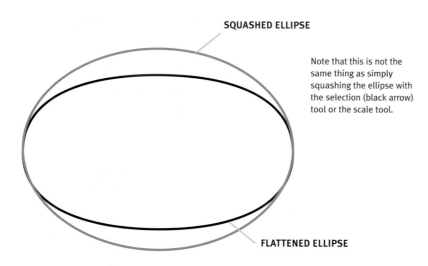

SQUASHED ELLIPSE

Note that this is not the same thing as simply squashing the ellipse with the selection (black arrow) tool or the scale tool.

FLATTENED ELLIPSE

ARTIST'S TIP

You don't have to flatten an ellipse every time you want to make a balloon. Simply create a single balloon and leave it on the "side" of your document (off the artwork). You can select it, copy, and paste to duplicate it every time you want to use it.

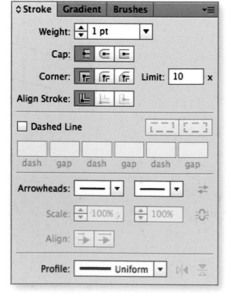

Normal speech balloons have a white fill and a black stroke. You can set the thickness of the stroke (the outline) using the Stroke palette.

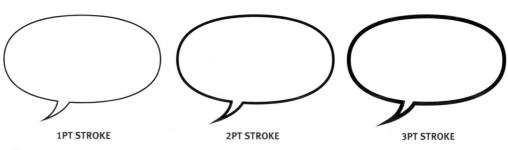

1PT STROKE **2PT STROKE** **3PT STROKE**

A value of 1 point is a good starting point, although they can be thinner or thicker according to your own preference.

The most important thing to remember when working with balloons is to start by trying to make a nicely shaped block of text.

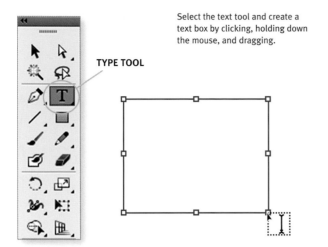

Select the text tool and create a text box by clicking, holding down the mouse, and dragging.

TYPE TOOL

USE THE
*CHARACTER
PALETTE* TO
FORMAT
TEXT!

You can then copy and paste text out of your script into the text box. Use the character palette to set the font and the leading, or line spacing. Consistency is key—pick a font and a point size for the text and stick to it. Never change the size of the text just to make it fit into a specific space!

ONE OF
THE KEY SKILLS
OF A LETTERER
IS THE ABILITY TO
SHAPE BLOCKS
OF TEXT...

ONE OF
THE KEY SKILLS OF A
LETTERER IS THE ABILITY
TO SHAPE
BLOCKS OF TEXT...

By using a text box you can guess the approximate size of the balloon you will need, although you should shape the text first. Can you tell which of these two blocks of text is preferable, and why?

Shape the text by inserting returns (line breaks) into the text so that the length of the lines forms a pleasing shape. Text in speech balloons is almost always center-aligned.

The aim is to produce a gentle curve at the end of the lines of text.

Return inserted to create a line break.

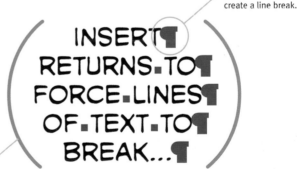

INSERT¶
RETURNS.TO¶
FORCE.LINES¶
OF.TEXT.TO¶
BREAK...¶

Notice the small plus sign that indicates that text has overflowed the existing text box.

USE THE
*CHARACTER
PALETTE* TO
FORMAT

USE THE
*CHARACTER
PALETTE* TO
FORMAT
TEXT!

If your text box is too small to hold all the text, you'll see an "overflow" symbol. You can use the selection tool (black arrow) to resize your text box until all the text appears.

ADDING A BALLOON TO ART

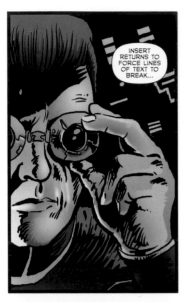

STEP 1 Once your text looks attractive, fit the balloon to the text, and then position it on the artwork.

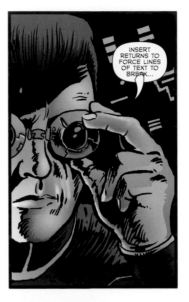

STEP 2 Now draw a tail. The balloon tail should point toward the speaker's mouth whenever possible; at the very least it should point to the head. Try to avoid tails that point towards a character's shoulders, elbows, or torso! If you are comfortable drawing Bezier curves with the pen tool you can make the tail curved, but a straight tail is acceptable.

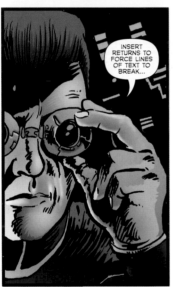

STEP 3 Merge the tail with the main balloon. Select both balloon and tail by clicking on the balloon with the selection tool (black arrow) and then holding down the SHIFT key and clicking on the tail. Illustrator's Pathfinder palette has several options for combining different shapes. In this case, use the Unite function to create a merged shape.

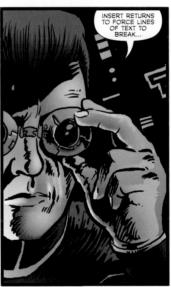

STEP 4 Sometimes you may want a balloon to sit flush to a panel border, as in the image above. This is a quick way to use space more efficiently and is easy to achieve using another of the Pathfinder functions (see step 5).

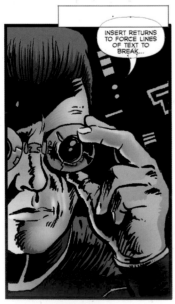

BEFORE

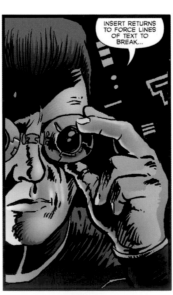

AFTER

Minus Front function on the Pathfinder palette

STEP 5 Simply draw a box over the part of the balloon you want to remove, select the balloon and the box (by SHIFT-clicking, as already described) and use Pathfinder ⤐ Minus Front.

DOUBLE OUTLINE BALLOONS

Double outline balloons are one way to emphasize dialogue. They don't necessarily denote shouting or increased volume (although they can), only that the reader should pay particular attention to what's inside the balloon.

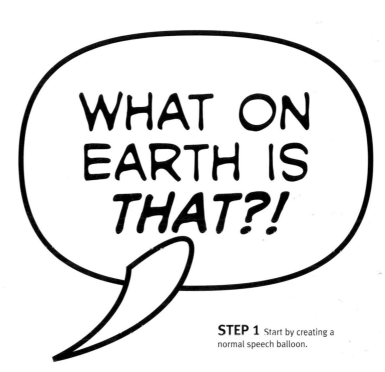

STEP 1 Start by creating a normal speech balloon.

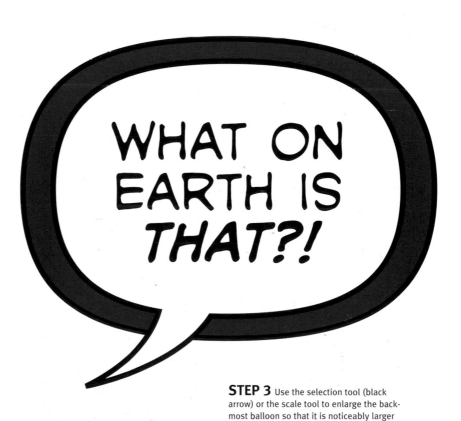

STEP 2 Select the main part of the balloon and Copy (either with a right click or with CTRL-C or CMD-C); then use Edit ····⟩ Paste in Back to create a copy directly behind the original.

When you create the second balloon, you won't see it because it's behind the first. However, it is already selected.

STEP 3 Use the selection tool (black arrow) or the scale tool to enlarge the backmost balloon so that it is noticeably larger than the one in front. Change the fill color to one that you find pleasing before merging the front-most balloon and the tail exactly as you would a normal speech balloon.

BURST BALLOONS

Burst balloons are used for shouting, screaming, alarm, or any kind of speech that may require extra emphasis. You can combine them with larger text, a bolder font, or both!

STEP 1 Draw a rough approximation of a balloon, using the pen tool to create an outline with straight edges. Try not to use too many points; the look of the burst balloon has relatively few points to distinguish it from the radio balloon, which we'll study later.

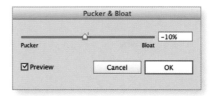

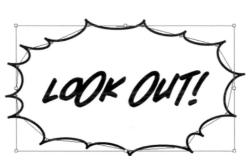

STEP 2 Then use Effect ····⟩ Distort & Transform ····⟩ Pucker & Bloat. For a burst balloon, you need to use a negative number; we'll see what happens with a positive number later. Check the Preview option to experiment with different values to see how the results look before you click "OK." Start with a value of about -10%, and see how the results change if you increase or decrease this number.

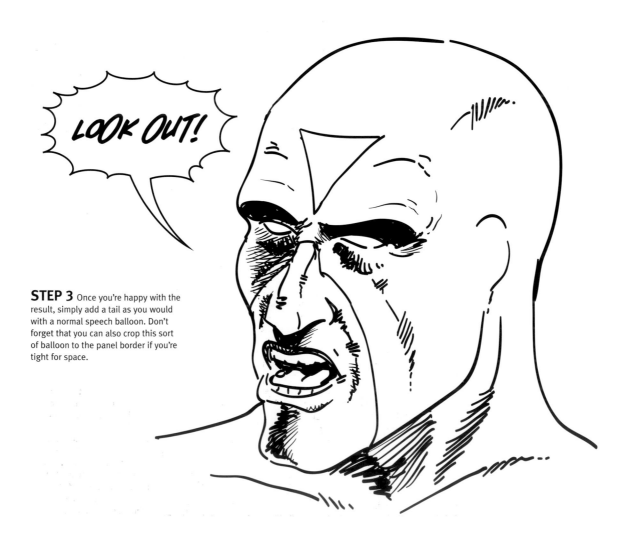

STEP 3 Once you're happy with the result, simply add a tail as you would with a normal speech balloon. Don't forget that you can also crop this sort of balloon to the panel border if you're tight for space.

THOUGHT BALLOONS

Also known as a thought bubble, the thought balloon has fallen out of fashion in this medium, but is actually a useful method of giving the reader quick and immediate insight into what a character is thinking or feeling in a way that narrative caption may sometimes fail to do. Note that text inside thought balloons is usually italicized.

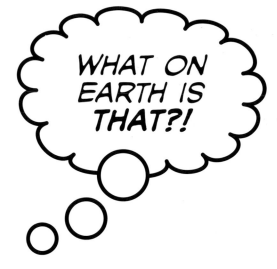

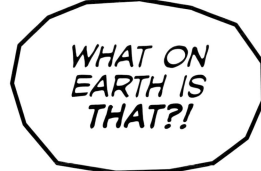

STEP 1 Thought balloons are almost the same as burst balloons. Using the pen tool, draw a rough shape. Make the points a little closer together, for reasons that will become clear in the next step.

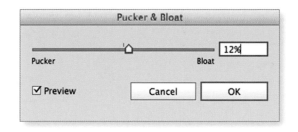

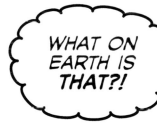

8% PUCKER & BLOAT

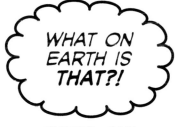

12% PUCKER & BLOAT

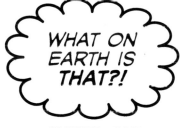

16% PUCKER & BLOAT

STEP 2 Use the Effects ·····⟩ Distort & Transform ·····⟩ Pucker & Bloat option again, but this time input a positive value. Experiment with different values and shapes that have fewer or greater numbers of points until you find a combination that pleases you.

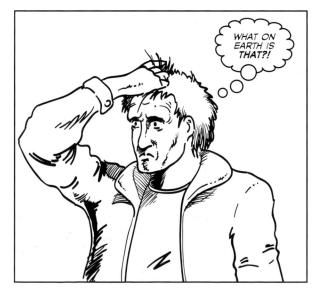

STEP 3 Once the balloon is positioned on the artwork use the Ellipse tool to draw a set of small circles instead of a pointer. Three or four circles is usually sufficient. Notice that they form a curved line toward the upper part of the character's head, and the circles get smaller the closer they are to the character.

RADIO BALLOONS

Radio balloons are used not only for dialogue coming from radio or television sets, but are often also used for dialogue spoken by the person on the other end of a telephone conversation. It can be used with or without a tail. The radio balloon is distinguished from a burst balloon by having more points and being more consistent. Consequently, it's made in a slightly different manner.

STEP 1 Start by drawing an ellipse. Go to the Object menu and select Object ----> Path ----> Add Anchor Points. This doubles the number of anchor points the ellipse has. Repeat this process a couple times. Don't forget that you can always experiment with the number of points that gives the most pleasing result because you only have to hit "Undo" to take a step back!

STEP 2 Apply the Pucker & Bloat effect with a negative number. You'll probably want a smaller value than you used for a burst balloon but, once again, experimentation is key.

KNIFE TOOL

STEP 4 You can also draw a normal, curved tail and split it with the knife tool. Simply draw a curved tail and drag the knife tool diagonally across the middle of the tail.

STEP 3 Put the radio balloon and text on the page and add a tail. Notice how radio balloons usually have a jagged tail. You can draw one by hand, using the pen tool.

STEP 5 Use the direct selection tool (white arrow) to nudge the bottom part of the tail up and across slightly; then re-merge the two elements to create the jagged tail.

WHISPER BALLOONS

Like thought balloons, whisper balloons are somewhat out of fashion today. Many letterers prefer the use of a lowercase lettering font to show that a character is whispering, but the use of a traditional whisper balloon is still perfectly valid.

A TRADITIONAL WHISPER BALLOON HAS ITALIC TEXT IN A BALLOON WITH A DASHED OUTLINE.

Although a normal balloon with lowercase text is more often preferred in recent years.

Create a whisper balloon exactly the same way as any normal speech balloon. Once placed on the artwork, use the "Dashed Line" option in the Stroke palette.

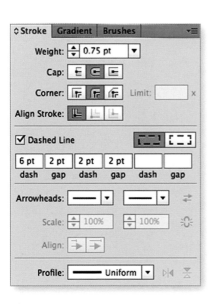

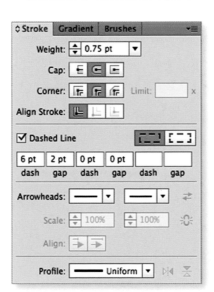

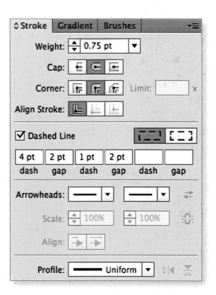

TRY TO EXPERIMENT WITH...

DIFFERENT STROKE VALUES...

TO FIND ONE YOU LIKE!

Experiment with different values to find one that looks most pleasing. A single value for the dash and the gap will produce a very even-looking line, so you may find more variation works better.

WEAK BALLOONS

Weak balloons differ from whisper balloons in that they are used to show dialogue that is quiet as the result of the speaker being ill, injured, or incapacitated.

A weak balloon should be drawn freehand, using the pencil tool.

PENCIL TOOL

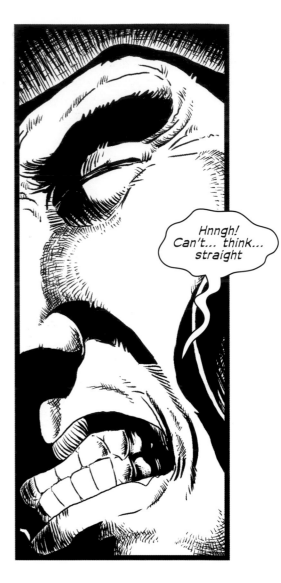

Hnngh! Can't... think... straight

Weak balloon with tail drawn using Pen tool...

Weak balloon with tail drawn using Pencil tool...

There will always be a gap between the start and end of the outline you draw; try to make this fall roughly where you need to draw in the balloon's tail and it is easy to cover up. You can either use a normal tail, drawn with the pen tool, or draw one freehand with the pencil tool. In either case, select and merge the balloon and tail the same way as with a normal speech balloon.

Pencil Tool Options

Tolerances

Fidelity: 0.5 pixels

Smoothness: 0%

Options

☑ Fill new pencil strokes

☐ Keep selected

☐ Edit selected paths

Within: 12 pixels

Reset Cancel OK

The pencil tool produces a wobbly shape for your balloon—exactly the effect you're looking for! Double-click the pencil tool to see other options. You can use the "smoothness" option to even out some of the roughness if you want a cleaner look for the balloon's shape.

Hnngh! Can't... think... straight

Fidelity: 0.5 px, Smoothness: 0%

Hnngh! Can't... think... straight

Fidelity: 2 px, Smoothness: 10%

Hnngh! Can't... think... straight

Fidelity: 5 px, Smoothness: 20%

JOINED BALLOONS

A huge balloon containing a lot of text is off-putting to the reader and an inefficient use of the space in a panel. By breaking the dialogue up into smaller sections and spreading it across several joined balloons, the effect is easier on the eye but still indicates to the reader that the speech is one continuous piece of dialogue.

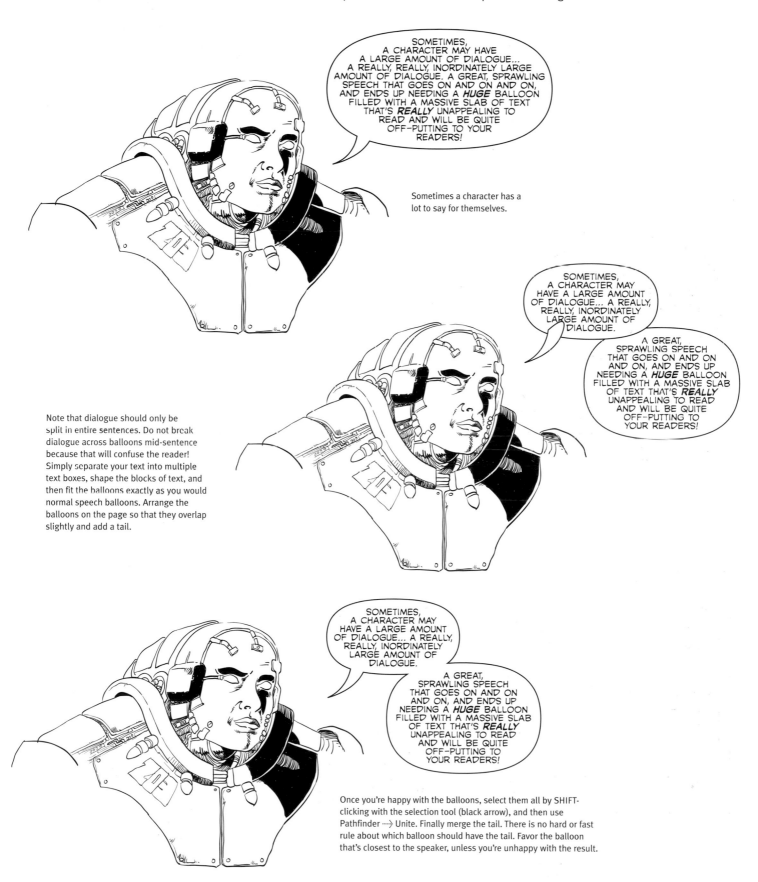

SOMETIMES, A CHARACTER MAY HAVE A LARGE AMOUNT OF DIALOGUE... A REALLY, REALLY, INORDINATELY LARGE AMOUNT OF DIALOGUE. A GREAT, SPRAWLING SPEECH THAT GOES ON AND ON AND ON, AND ENDS UP NEEDING A *HUGE* BALLOON FILLED WITH A MASSIVE SLAB OF TEXT THAT'S *REALLY* UNAPPEALING TO READ AND WILL BE QUITE OFF-PUTTING TO YOUR READERS!

Sometimes a character has a lot to say for themselves.

SOMETIMES, A CHARACTER MAY HAVE A LARGE AMOUNT OF DIALOGUE... A REALLY, REALLY, INORDINATELY LARGE AMOUNT OF DIALOGUE.

A GREAT, SPRAWLING SPEECH THAT GOES ON AND ON AND ON, AND ENDS UP NEEDING A *HUGE* BALLOON FILLED WITH A MASSIVE SLAB OF TEXT THAT'S *REALLY* UNAPPEALING TO READ AND WILL BE QUITE OFF-PUTTING TO YOUR READERS!

Note that dialogue should only be split in entire sentences. Do not break dialogue across balloons mid-sentence because that will confuse the reader! Simply separate your text into multiple text boxes, shape the blocks of text, and then fit the balloons exactly as you would normal speech balloons. Arrange the balloons on the page so that they overlap slightly and add a tail.

SOMETIMES, A CHARACTER MAY HAVE A LARGE AMOUNT OF DIALOGUE... A REALLY, REALLY, INORDINATELY LARGE AMOUNT OF DIALOGUE.

A GREAT, SPRAWLING SPEECH THAT GOES ON AND ON AND ON, AND ENDS UP NEEDING A *HUGE* BALLOON FILLED WITH A MASSIVE SLAB OF TEXT THAT'S *REALLY* UNAPPEALING TO READ AND WILL BE QUITE OFF-PUTTING TO YOUR READERS!

Once you're happy with the balloons, select them all by SHIFT-clicking with the selection tool (black arrow), and then use Pathfinder ·····⊰ Unite. Finally merge the tail. There is no hard or fast rule about which balloon should have the tail. Favor the balloon that's closest to the speaker, unless you're unhappy with the result.

LINKED BALLOONS

Linked balloons connect lines of dialogue from the same speaker that are not continuous. If a character has two consecutive lines of dialogue that are not directly related, the balloons should be linked rather than joined.

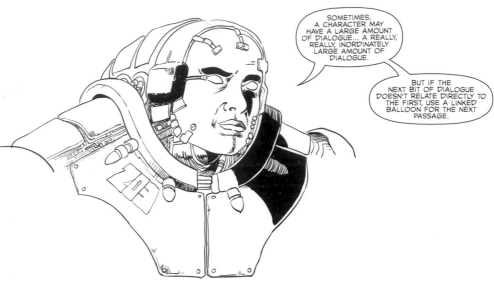

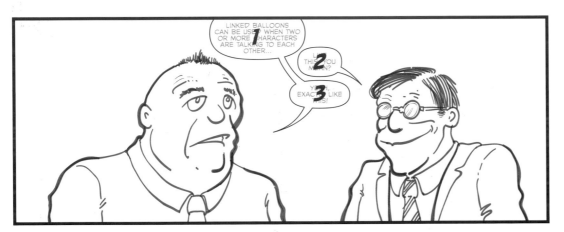

Use linked balloons when there is back-and-forth dialogue between two characters. Simply position the balloons so that it is clear in which order they should be read.

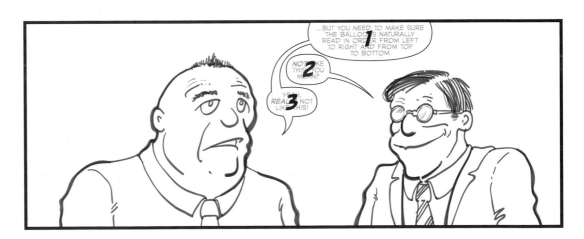

Remember that the reader will want to read the balloons the same way they read normal text: left-to-right and top-to-bottom. It's okay to have a little deviation from top-to-bottom if the eye travels naturally across the balloons from left-to-right, but be careful to ensure a clear reading order.

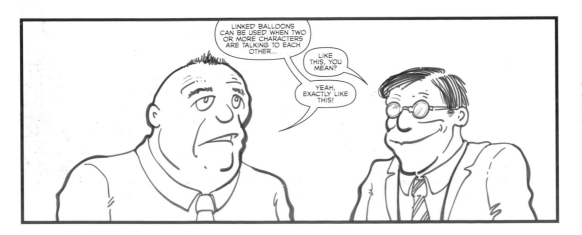

Once you're happy with the positioning, simply add a tail to either the first or last balloon in the series of linked balloons, depending on which is closest to the speaker, and then draw a linking tail. Then simply select the elements and merge them with Pathfinder ····> Unite, as before.

CAPTIONS

Captions are reserved for narrative text, either third person or first person. They can also be used for voice-over text—dialogue that is spoken aloud by a character not present in the current scene. In this case, the text also uses quotation marks.

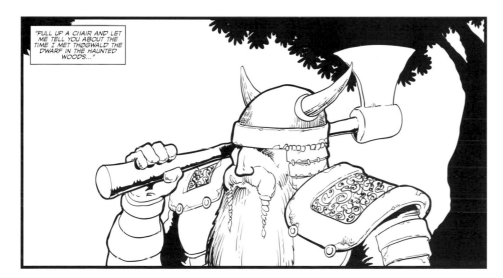

Caption text is usually italicized and centered, but it can also be aligned left.

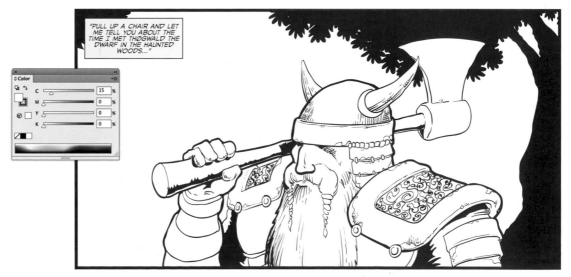

If a story has multiple narrators, consider using color-coded caption boxes specific to each character.

PLACEMENT & FLOW

It may seem obvious, but it's vitally important to remember how your readers are going to read your pages. All the beautifully shaped balloons and carefully chosen fonts in the world won't help if the reader can't determine in which order they are supposed read the balloons!

Remember that the reader will want to read the page the same way as any normal page of a book or magazine: starting at the top left-hand corner, reading from left to right, and top to bottom. Obviously, if you're working in Hebrew or Arabic then the reading order changes! We're talking here about the standard Western reading order.

Before we get to the actual lettering aspect of this section, it's important to understand the fundamentals of page layout, even if you are lettering someone else's artwork.

Look at this arrangement of panels making a page layout and number them 1-4 in the order they should be read.

Now try with this layout.

Next number these panels 1-6.

A comic page should be intuitive to read; the reader should never have to stop and determine where to go next. While it's not necessary to slavishly follow a grid when designing a panel layout, the page should always start with an easy-to-follow grid to ensure that reader's eye flows effortlessly through the story.

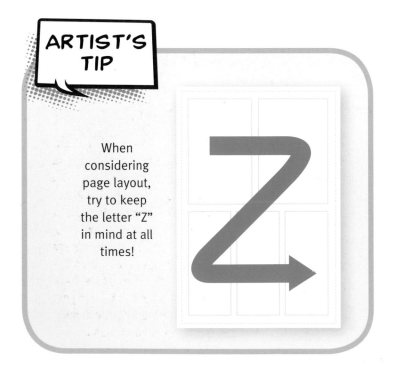

ARTIST'S TIP

When considering page layout, try to keep the letter "Z" in mind at all times!

Try to number the reading order in this layout. Panels 1 and 2 are easy to read, but Panels 3 and 4 present the reader with a quandary. Do they give preference to left-to-right or top-to-bottom? This is confusing, and a layout like this should be avoided.

Note, however, that the reverse is perfectly readable.

With this principle of reading order firmly in mind, the letterer's priority is to ensure that a clear flow leads the reader's eye naturally through the story within each panel. Note that in each case below the reader can clearly see that the reading order of the balloons follows left-to-right and top-to-bottom.

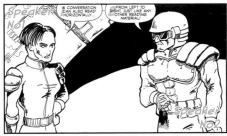
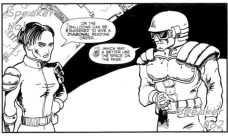

VERTICAL **HORIZONTAL** **DIAGONAL**

Sometimes the art may be more challenging for the letterer to work with. In the example below left, the first character to speak has been drawn on the left of the panel, which is great because you will want their balloon to be the left-most so that it is read first.

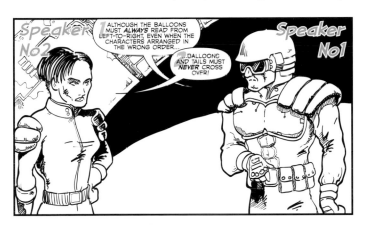
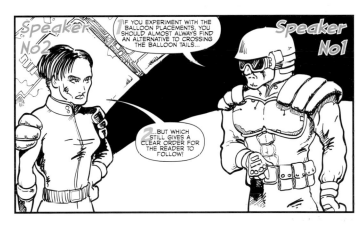

However, (surprisingly often!) you may find that the artist has drawn the first character to speak on the right and the second on the left (below right). There are many lettering conventions that can be bent or broken, but one that you should always, always observe is that balloon tails must never cross! With a little experimentation, it's almost always possible to find an acceptable compromise.

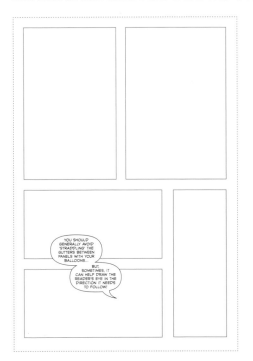

Generally, floating speech balloons across gutters (the white space between panels) should be avoided. However, this can be a useful technique for bridging panels and drawing the reader's eye in a direction it might not otherwise travel naturally.

The same is also true of sound effects, which can be used to link panels together that might not otherwise be obviously connected in the reading sequence.

ARTIST'S TIP

If you're lettering pages that have been drawn by someone else, you may sometimes find yourself confronted with a layout that will be difficult for the reader to follow. Don't forget that you have the benefit of reading the script! Try to approach each page as if you were the reader, and ask yourself if you can read the page clearly and easily.

SOUND EFFECTS

Where sound effects are concerned, there is some good news and some bad news. The good news is that sound effects are technically simple to create. The bad news is that doing them well is tricky and is only ever the product of practice, experience, and more practice!

Sound effects are not simply *onomatopoeia*: words whose spelling and pronunciation are derived from the sound it describes, like "boom." It is a necessary function of the sound effect to visually complement the action or sound it is signifying. This is why "crack" or "crash" are often rendered on the comic page as "krak" or "krash."

Notice how the hard angles of the "K" visually represent the harsh, abrupt sound better than the gentler curves of the "C." Likewise, a repeated "O" visually complements the rolling sound of an explosion.

A letter like "E" creates lateral travel across the page for the reader's eye with its three horizontal strokes. As such, it's excellent in a sound effect for a skidding car.

This same letter, however, works against the visual effect of an explosive sound effect.

Just as with dialogue, upper- and lowercase denote different levels of loudness and dramatic effect. So, for example, a superhero punch is likely to be uppercase.

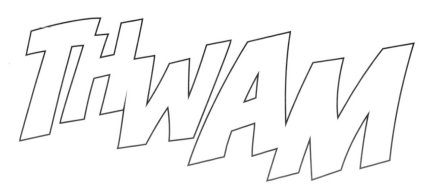

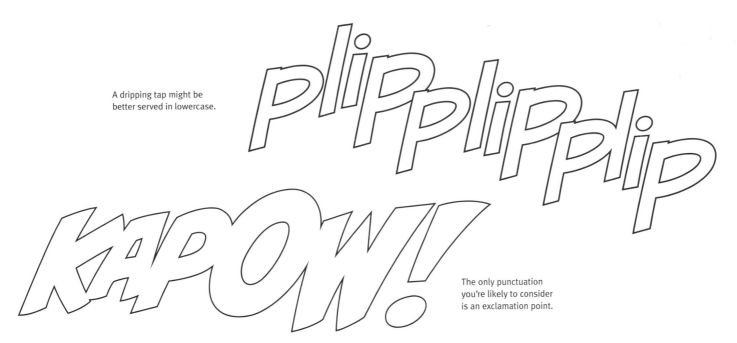

A dripping tap might be better served in lowercase.

The only punctuation you're likely to consider is an exclamation point.

Punctuation is a slightly contentious issue, with opinion divided amongst letterers. There is no right or wrong. Personally, I choose no punctuation because it is redundant if your word is in large, bold, colored type. Additionally, the exclamation point is often difficult to harmonize with the general design of a sound effect. It does not sit well with angular geometric fonts or rounded curvy ones. It also has a tendency to create tangents with the rest of the artwork (see sidebar).

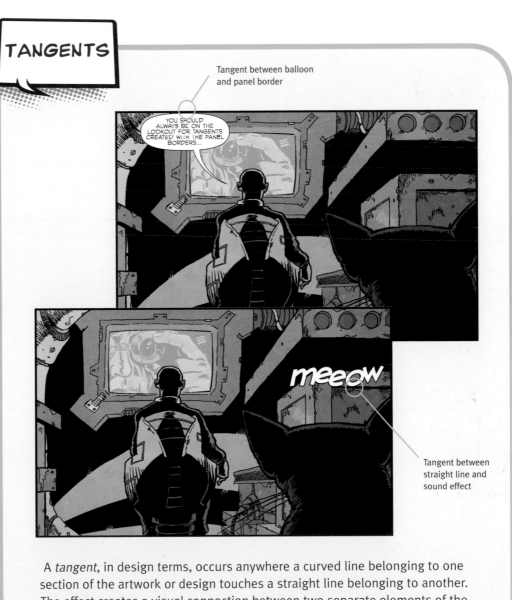

TANGENTS

Tangent between balloon and panel border

Tangent between straight line and sound effect

A *tangent*, in design terms, occurs anywhere a curved line belonging to one section of the artwork or design touches a straight line belonging to another. The effect creates a visual connection between two separate elements of the page where none is intended, with the unwanted effect of "flattening" the design. Always be on the lookout for tangents when lettering.

When creating sound effects, the first thing to consider is the choice of font. The primary sources of comic lettering fonts are Blambot (www.blambot.com) and Comicraft (www.comicbookfonts.com), although there are many independent font designers whose works can be found elsewhere online.

It's tempting to use a new font every time the script calls for a sound effect, but this quickly leads a visually confusing strip. A good rule of thumb is to pick a "family" of three fonts to do the vast majority of your lettering on any given strip. If the artwork is cartoony, humorous, or whimsical you might select different fonts than you would for a strip where the tone is more serious or horror-oriented. Creating the effect is quite straightforward. Let's try creating one together.

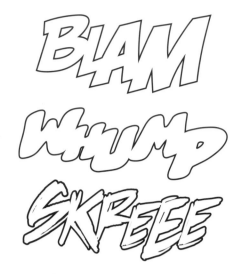

I tend to pick one font for general-purpose effects, another for "harder" sounds, and a third for "softer" sounds. This doesn't mean that you can't bring in additional styles when appropriate, but you should consider doing so as the exception, rather than the norm.

STEP 1 Start with normal, editable text.

STEP 2 Next convert it from text into editable shapes, using the Create Outlines function.

STEP 3 Don't simply leave your text as you've typed it; add a little bounce! Ungroup the letters first, and then scale some up and some down. Arrange them so that they fit well on the art and look pleasing to you. Remember that larger is "louder" and smaller is "quieter," so you can create effects that trail off or look like they're increasing in volume.

Add shape to area function

STEP 4 At this point, you can leave the individual letters as separate shapes, in which case you should use the Group function so that you can move them around as if they were one object. Alternatively, you can merge the letters using Pathfinder ⟶ Add Shape To Area.

If you favor a heavy outline (stroke) you may find that simply increasing the stroke weight delivers some unattractive results.

This is easily rectified in the "Appearance" palette simply by dragging the "Fill" element so that it sits above the "Stroke."

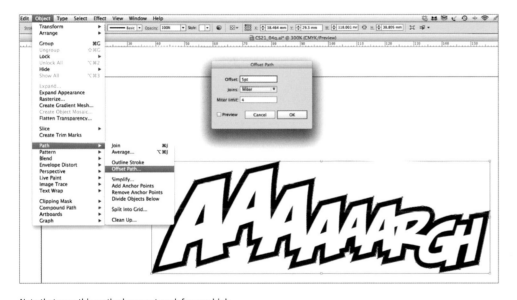

Note that even this method may not work for very high stroke thicknesses, and you may have more success using the Offset Path function to create very heavy outlines.

You can experiment with colored or even gradient fills, but always remember that the sound effects are meant to complement the artwork, not overwhelm it!

If the artist has laid out the page well so that the eye flows naturally through the story, then it is imperative that your sound effect work respects that flow. If the flow breaks down and the artist has created a point on the page where the reader is unsure where their eye should go next, then you — as letterer — may be able to fix that.

CHAPTER 4

COMIC STRIPS

WITH ALEX HALLATT

Most popular comic strips have recurring central characters in a specific location. My comic strip, *Arctic Circle*, is about three immigrant penguins in the Arctic. When I created the strip more than 20 years ago, I didn't really enjoy drawing. I thought the Arctic would give me lots of lovely, blank, white space with no complicated backgrounds. The black-and-white characters (penguins and a polar bear) would be ideal for newspaper pages, which were rarely in color at that time. Although I sometimes still use white backgrounds—especially when close to a deadline—I now love drawing and have engineered my Arctic universe to include a lot more than snow, sea, and ice.

In this chapter we'll explore how to develop a comic strip from start to finish.

CREATING A COMIC STRIP

If I were to come up with a comic strip now, it would be very different. I would have a female character from the beginning—Gwen the penguin didn't appear until a few years into the strip. I would also make sure the characters looked and acted very different, to help new readers quickly get to know them. With that in mind, I'll create a comic strip from absolute start to finish and guide you to do the same.

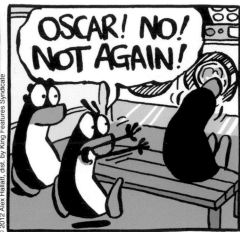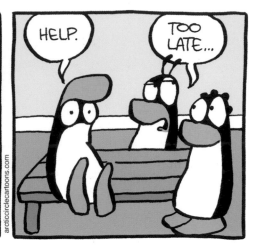

My penguins Oscar, Ed, and Gordo look almost identical, apart from the tops of their heads.

CHARACTER DESIGN

In newspaper strips, characters are confined by the dimensions of the comic strip panels (or boxes). It would be fun to have a tall character paired with a short one, but it's difficult trying to fit them in the panels without making them too small.

Remember that newspapers strips are often printed very small—typically only a couple of inches high!

This is one of the reasons why kids and animals work so well in comic strips—they fit perfectly!

There have been plenty of boy (or man) and pet animal strips, such as *Peanuts*, *Calvin & Hobbes*, and *Garfield*, in syndication. So I'd like to try something different and introduce a girl. But even that is a bit dull. Let's change the dog to... an alien.

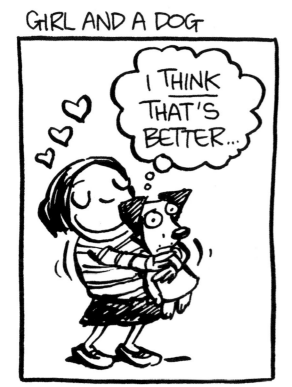

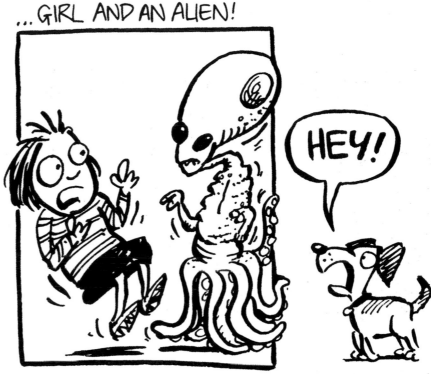

Now this interests me! It's your turn—go ahead and create a couple of characters that interest you and fit into a comic strip panel.

Start with characters that you like, but chances are they won't look quite right at the beginning. This girl and alien don't look any different from other cartoon girls and aliens. The alien also looks scary and is too complicated to draw a lot. Characters need to evolve. Once you have your ideas for your characters, do some sketching, trawl through photo references on the Internet, and play with lots of shapes and forms. Try to think of as many different looks as you can.

Your final characters should be easy to reproduce in newsprint (poor quality paper and at small size), simple enough to draw every day, and different enough to be instantly recognizable.

ARTIST'S TIP

It's worth considering that if your strip takes off, you will have to draw these characters day in and day out.... so you better like them!

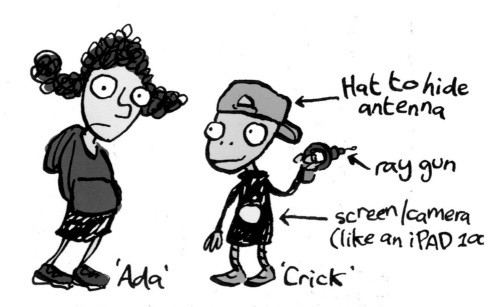

These are my favorite looks for now. But like every comic strip character, repeated drawing means they will evolve over time—consider how Snoopy went from a little dog on all fours to a full-sized, stand-up character.

WHAT ARE YOUR CHARACTERS LIKE?

Physical differences help new readers differentiate comic characters, but it also helps if characters behave very differently. A good double act is the smart/mean guy and his dumb/kind foil. This sets up the characters for writing that exploits the conflict in their characters.

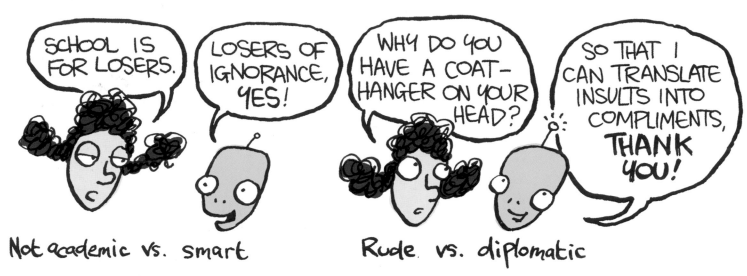

Not academic vs. smart

Rude vs. diplomatic

Note what your characters are like—mean/kind, smart/dumb, gregarious/shy, etc. You'll know that your characters are ready for your strip when they begin to come alive on the page and suggest dialogue to you. Good characters are fun to draw and write for! When you have been doing your strip for a while, it starts to feel like the characters are writing the strip for you. You give them a situation and they just act it out on the page.

ARTIST'S TIP

To make your comic strip memorable for new readers, keep it simple and make your characters look and behave very differently from each other. Try to start with just two characters to help readers get to know your strip more quickly.

COMIC STRIP LOCATION

As with characters, location choice for your comic strip can determine how easy it will be to write and draw.

Having your characters at a table or bar, like in *Garfield*, makes it a cinch to draw, but it doesn't set the strip up for visually interesting situations. However, if you are a great writer and the characters are strong, you may not need much else.

Your characters may naturally fit with a location, or you can fit them into a strange one, which can be fun with normal characters. A girl and an alien suggests a setting of either the alien's world or the girl's world, and putting the girl in the alien's world would make it great fun to draw!

If you lean toward writing science fiction, this could be the way to go, and you could write about the parallels between the alien world and ours. But it's not for me. I'm more drawn to writing about the girl's world, drawing on my own childhood and observations of the contemporary world around me.

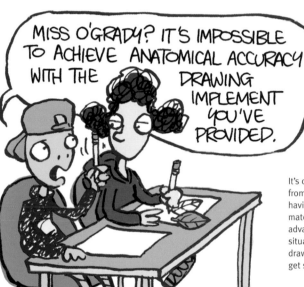

It's often easier to write from what you know, and having a lot of source material can be to your advantage. So think of situations you'd like to draw and write about and get sketching!

ARTIST'S TIP

Many syndication contracts are good for 10 years! If you're serious about writing a daily comic strip, take the time to develop one you want to spend a decade with!

Once you have the setting for the characters you've created, it's time to write some comic strips!

WRITING FOR COMIC STRIPS

GETTING SOME FUNNY IDEAS

Sketching your characters and location may have already suggested some ideas to you. Characters and their situation provide structure for writing, and the writing reinforces the characters. Don't break with character for the sake of a good gag; you will confuse readers, who are getting to know your character.

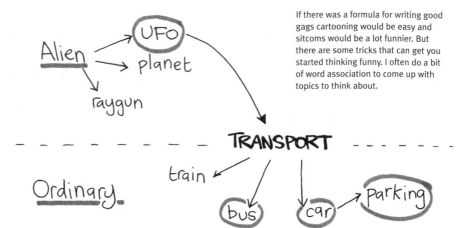

If there was a formula for writing good gags cartooning would be easy and sitcoms would be a lot funnier. But there are some tricks that can get you started thinking funny. I often do a bit of word association to come up with topics to think about.

Use word association to come up with some comic topics and try each of the six tools on these pages to write some funny ideas.

SLAPSTICK
sometimes works.

JUXTAPOSITION
of odd subjects can create funny situations.

OBSERVATIONAL HUMOR works when your readers identify with a subject.

I KNOW... YOU WAIT ALL YOUR LIFE FOR A UFO, AND THEN THREE COME ALONG AT ONCE...

BUS

WISH FULFILLMENT is a powerful writing tool— we'd like to see parking wardens be outwitted!

NO PARKING

OFFENDERS WILL BE TOWED

We've got a bit of a problem...

ARE YOU SURE YOU'VE MOORED YOUR UFO SECURELY?

FRAYED KNOT...

PUNS can be worth trying, but if your comic is syndicated worldwide, they may not translate into other languages.

THAT SUCKS!

VULGARITY is a last resort. You may get some laughs if you use toilet humor, swearing, or sexual innuendos, but you'll be writing for a non-family audience and your comic won't get into syndication.

TIMING & STORY ARCS

Most syndicated comic strips (and web comics with a good readership) are "gag-a-day." The strength of comic strips over single panel gags is using the timing that the multi-panel format provides to set up the gag, build on it, and provide the punch line. Here are some rough examples that use some of the ideas I came up with. These pencil roughs are what I would send an editor for review.

Though the number of panels changes the timing, there is usually a set-up and a punch line unless the strip is a single panel—which purists would say isn't a comic strip at all!

You may find that some of your ideas fit better in a four- or even five-panel strip than a three- or two-panel strip. Go ahead and rough up some panels with your comic ideas. Don't worry about being too neat; it is the writing and the timing of the strip that is important at this stage.

As a syndicated cartoonist, I'm encouraged by my syndicate editor not to have story lines that are too long. A casual reader should be able to read *Arctic Circle* on any day for the first time and find something in it that entertains them.

Sometimes you can write a gag-a-day strip and still tell a story that stretches over the week, or even a couple of weeks. This works best if you use a story arc, which is similar to the way writing is structured for the strip (set-up, build, punch line/peak) but over a longer time frame. See page 99.

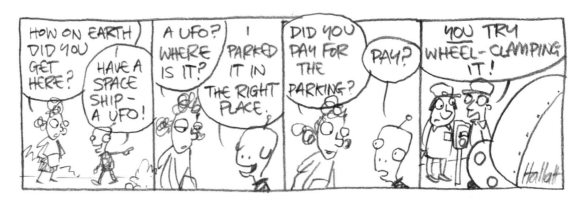

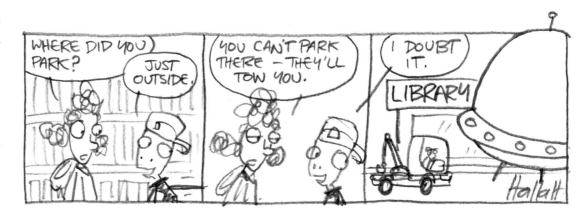

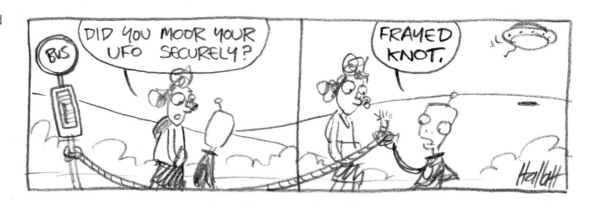

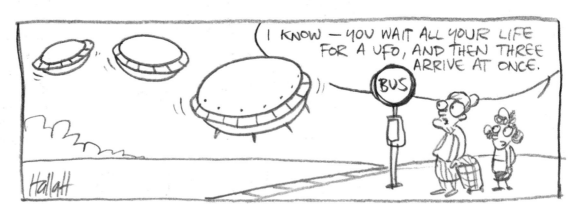

This story arc could work to introduce the alien to the girl, building up to how he ends up in the family—being accidentally adopted instead of a human child (peak drama)—and settling into his new family. If you like telling stories, you can create your own series of comic strips using the story arc as a guide to the level of drama.

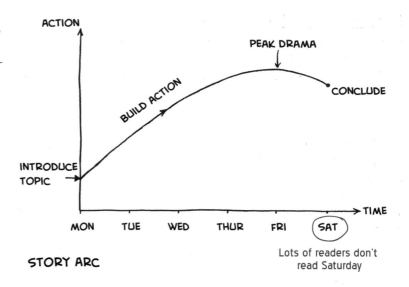

STORY ARC

Lots of readers don't read Saturday

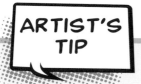

ARTIST'S TIP

Make sure that the peak of the action doesn't fall on a Saturday! Some papers aren't published then, and many Internet sites get less traffic on the weekend.

EDITING & REVIEW

Editing is just as important as writing. Once you have written your strips, let them sit overnight before re-reading. This will help you spot mistakes and tighten up the copy (text). Comic strips don't have a lot of room for art, let alone rambling text, so make it as concise as possible. Today's busy readers might skip text-heavy strips. If you have more than 50 words in a strip, it is probably too long. Cut, cut, cut the copy and get it as punchy as possible. Looking at your roughs again can also help you see how to improve them visually.

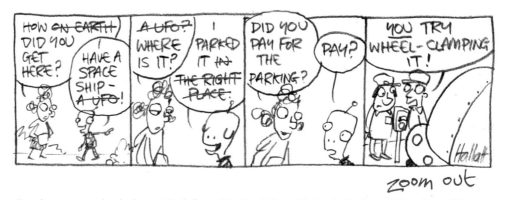

Try to have someone else check your strips before putting them in the public domain. It's also great if you have a friend or family member who will read your comics and provide constructive criticism before you put them on the web or send them to the syndicates. Only publish your best work. Write what interests you. Entertain yourself. If you don't find your strip entertaining, no one else will. Some cartoonists write for an audience, but it isn't normally an audience of millions—it's an audience of one. Write to make you, your best friend, or your sister laugh.

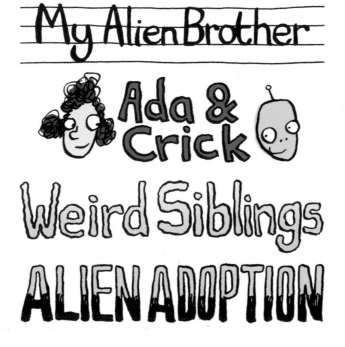

"Alien Adoption" sounds a bit like "Alien Abduction" and might be more memorable than "My Alien Brother." But "Ada and Crick" (after Ada Lovelace and Francis Crick, two scientists I greatly admire) sounds a lot friendlier. Both "Ada and Crick" and "Alien Adoption" are close to the start of the alphabet, and that makes the strip more likely to be seen when scrolling through a lot of names. It's hard to choose between them, so I'll run them by some friends.

NAMING YOUR STRIP

Naming a strip is tough. *Peanuts* really didn't have much to do with Charlie Brown and Co., but it worked. While it shouldn't be more important than the content, the title may be the first thing that makes someone consider reading your strip—especially if it is just a link on a website. Brainstorm and come up with at least four names for your strip and try them out on friends and family to get feedback before you decide on what works best for you!

COMIC STRIP FRAMEWORK

After you have written your strips and roughed out the panels, the next step is to draw them for publication. Amateur comic strips often have text and drawings that are jammed into too small a space. Spending time on getting your borders, lettering, and word balloons to look right will make your comic look more professional. Additionally, the way you lay out the drawings, text, and strip framework (borders, gutters, and balloons) will give your strip a certain look that makes it easier to recognize when scanning through a page of comics.

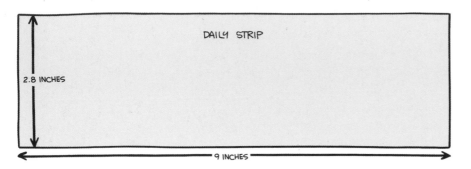

If you are designing your strip for newspapers, it needs to be the same size every weekday and a different set size for Sundays. Web comics can be drawn at different sizes, but many web cartoonists keep to a consistent size to allow for easier layouts in book collections. Here I've shown the comic strip sizes recommended for submission by my syndicate.

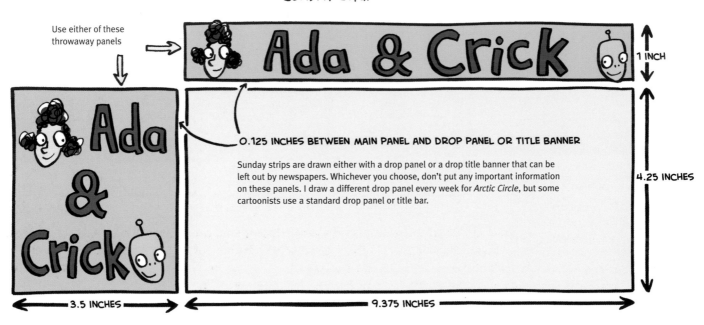

Sunday strips are drawn either with a drop panel or a drop title banner that can be left out by newspapers. Whichever you choose, don't put any important information on these panels. I draw a different drop panel every week for *Arctic Circle*, but some cartoonists use a standard drop panel or title bar.

You can draw bigger than the suggested sizes above—and will probably want to—but remember that newspaper comics are printed smaller than these sizes. When your comic is shrunk down and squished onto poor-quality newsprint, it will be more difficult to read than the original drawn large on smooth Bristol board or cartridge paper.

I draw *Arctic Circle* at just over 11 x 3.5 inches. That way I can print my templates on a normal printer, scan the inked strip on a regular scanner, and I won't draw too much detail that will be lost in the newsprint. You can create templates for different numbers of panels, add text lines for lettering, and even the rough pencil art and print them out to draw over.

This blue (7% cyan) doesn't reproduce when the black line art is scanned into my computer. It also saves a lot of pencil erasing, which can turn into a real chore if you are working on batches of a week or two's worth of strips. Alternatively, you can pencil out the strip before inking, or do it all on computer. Whichever way you work, you should put in the lettering first, because you can adjust the size of the drawing, but the lettering size should be constant.

LETTERING

In Chapter 3 you learned about lettering techniques. Personally, I am a big fan of hand lettering and use uppercase (capital letters) for most of my dialogue. I've also seen great strips use a mix of upper- and lowercase lettering. A well-chosen font can suit the look of some strips. There are several websites that carry fantastic fonts designed specifically for comics, and fonts can even be made from your own handwriting. If you hand letter, take great care to ensure that the text is readable, especially when shrunk down to newspaper-print size (or when on a low-resolution computer screen). Lettering guides are almost essential for this, unless you are a handwriting genius! Sometimes I use black printed lines and a light box, but this has the potential to move around under my drawing, so I use a printed blue template for most of my strips and letter directly within those guidelines.

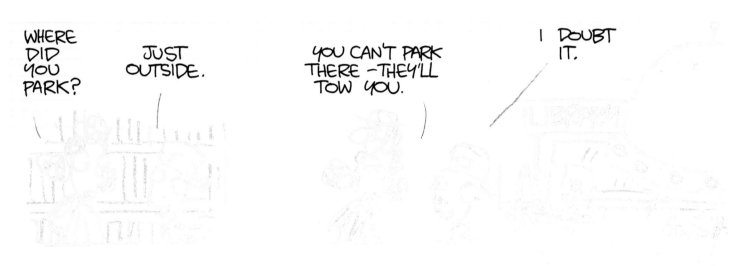

You should neatly letter right onto your roughly drawn strips.

BORDERS

As discussed in the previous section, the number of panels can vary. Some cartoonists choose to keep the number of panels the same every day. For instance, Charles Shultz drew *Peanuts* mainly as a four-panel strip for decades, only changing to a three-panel strip in the 1980s. However, I prefer to let the writing dictate the number of panels that will work the best. Regardless of how many panels you use, you need to draw the border of each one and leave a gutter between them.

A gutter acts like a paragraph break in a story. It causes the reader to pause and prepare for the next panel, and it is an important part of a comic strip's timing. It has also become critical real estate for advertising, where you can find out more about the comic and its creator(s), with website addresses, Facebook page URLs, and even Twitter handles. Website addresses are as important a part of the comic as your signature. This information is often put in the gutters of the strip, as you will see in the next section, "Drawing the Comic."

Some cartoonists draw borders with a ruler, some use printed templates, some draw freehand, and others add borders using a computer. As long as you can find a way to ensure that your borders fit within the necessary dimensions, it doesn't matter how you do it. Try out different methods, line widths, and spacing to see what works with your style of drawing.

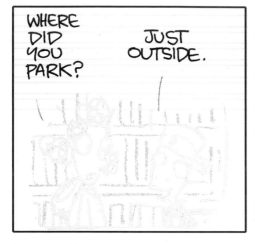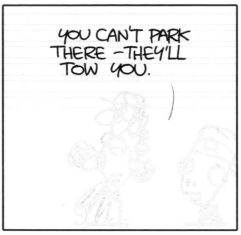

Computer-ruled lines

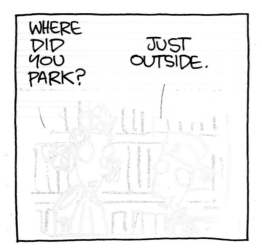

Thin, hand-drawn lines

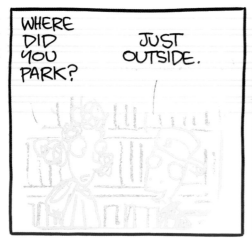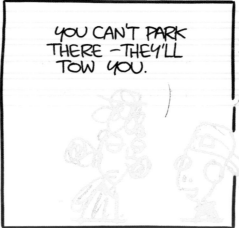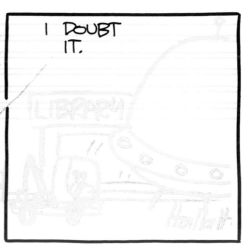

Thick, hand-drawn lines—the way I like my comic strips!

BALLOONS

As with borders and lettering, you can use a computer to design your word balloons, but they can look lifeless and dull. By drawing them freehand with a pen or brush they will all be different from each other, and the slight inconsistencies will add visual interest. Practice first and do a few warm-up exercises, drawing curves and circles beforehand, to make your balloons smoother. After I have done my lettering, I ink most of my balloons freehand, though it sometimes pays to use pencil if the layout is more complicated.

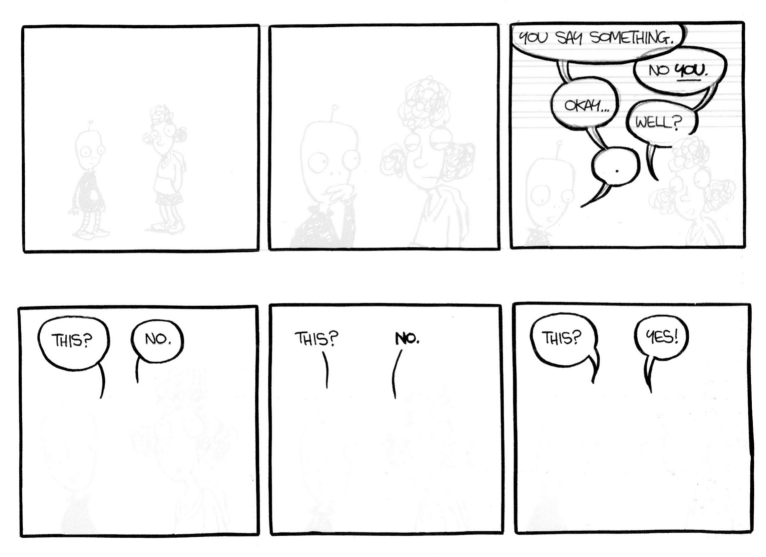

Experiment with different looks before settling on what is right for your strip.

Some Dos & Don'ts

I've broken a few of these along the way, but in general you should obey the following rules.

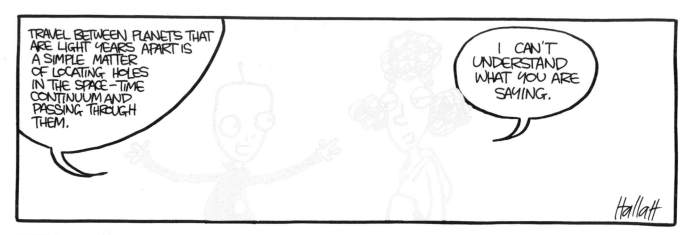

RULE 1 Make sure other people can easily read your lettering at the size it will be printed.

RULE 2 Don't allow words to drift too closely to the edges of word balloons and center text in the balloon, even if you are aligning left or right.

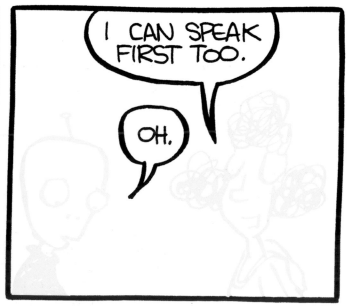

RULE 3 Ensure that the order of the balloons reflects the order in which the characters are speaking. People will read from left to right or top to bottom.

RULE 4 Don't cross word balloon tails. Redraw the panel, or rearrange the word balloons.

RULE 5 Avoid loose tails; they should point to the character who is speaking—ideally to their head.

RULE 6 If you overlap your drawing into a word balloon, don't let the line cut into their eye level.

ARTIST'S TIP

Be creative: it doesn't matter if you break a few rules, as long as the strip is legible. The way you letter and draw borders and balloons is a huge part of the your strip's "look." The danger of ruled borders, computer-drawn balloons, and a font for the text is that your cartoon will just look like a lot of other strips and won't draw attention.

DRAWING THE COMIC

India ink is great for reproduction or creating fade-proof originals to exchange with other cartoonists or sell to fans. Brush felt pens have evolved to mimic the style of a brush with the control of a pen, but you may prefer to use felt tips, rollerballs, or even just a pencil (which you can darken on a computer). If you want to work directly on a computer, versions of all these tools are available in drawing programs such as Adobe Photoshop, Manga Studio®, or CorelDRAW. Experiment and find the inking tool that best suits your drawing style. The way you ink over your roughs is up to you, and it will affect the style of the completed strip.

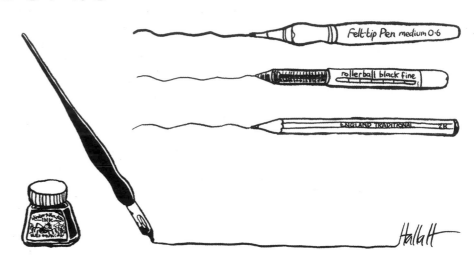

I letter my comic strips with a uni-ball pen that has waterproof, fade-proof ink. To draw borders I use a dip pen, india ink, and a 63.5 nib. I use the same nib to ink most of the artwork, except for fine detail, when I switch to a range of smaller nibs that litter my desk. I use a variety of smooth, heavyweight cartridge papers that I can feed through my printer to print templates.

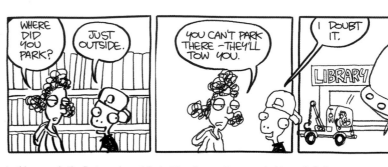

In this example the first panel was inked with a dip pen, the second with a rollerball pen, and the third with a pencil that was digitally darkened.

ARTIST'S TIP

Experiment with lots of materials to see what you like. I used a certain nib with my dip pen for years until it didn't seem to respond to the same pressure. Then I decided to switch to my current nib of choice.

I usually let my ink dry overnight, but in a pinch you can use a hair dryer! Once the ink is dry I tidy up my illustration before scanning it. The blue line saves a lot of time erasing pencil lines, but if I've done any redrawing with pencil, I use a kneaded eraser to remove it cleanly. This is also a good time to fix mistakes with correction fluid, but you can also do this on the computer.

I scan my originals at high resolution on a black-and-white setting so that only the black lines will be picked up. It's important to scan at a size that is the same as, or larger than, the file you will send to be printed. Small, low-resolution files lose quality if they have to be enlarged.

Most cartoonists tidy and color their work using Photoshop or other digital imaging software. Open your scanned file, rotate, convert to gray scale, and use Filter ····⟩ Noise ····⟩ Dust & Scratches to remove any dust and scratch marks from the work.

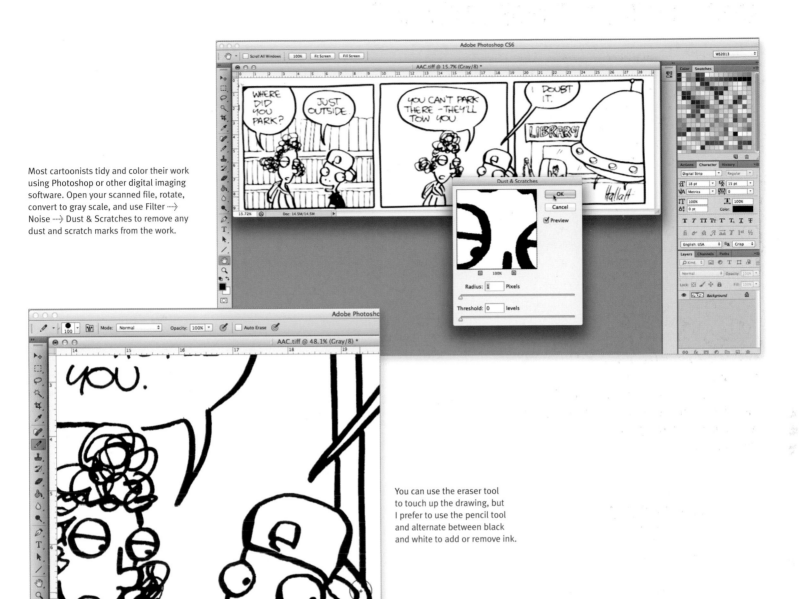

You can use the eraser tool to touch up the drawing, but I prefer to use the pencil tool and alternate between black and white to add or remove ink.

Straighten and crop the illustration—you can accomplish both tasks with the crop tool.

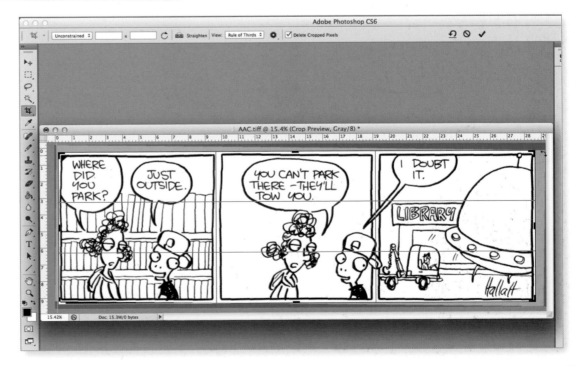

To fill in areas of solid black, select them with the wand or lasso tool, expand the selection by four pixels (Select⸱⸱⸱⸱⸱➔Modify⸱⸱⸱⸱⸱➔Expand) to ensure the area is completely filled, and fill with the black foreground color.

With the black artwork complete, now is the time to add copyright and website information to the gutters or other free areas of the strip before flattening the layers.

My syndicate requires both black and color versions of daily comic strips. I simply send a flattened TIFF file of the black version. Adding color is more challenging because the color and black are printed separately in newspapers. To avoid muddy colors you must keep black out of the color areas. You also need to overlap the black line over the color areas to prevent white gaps from printing when print registration isn't exact. The following process takes care of these requirements for color printing.

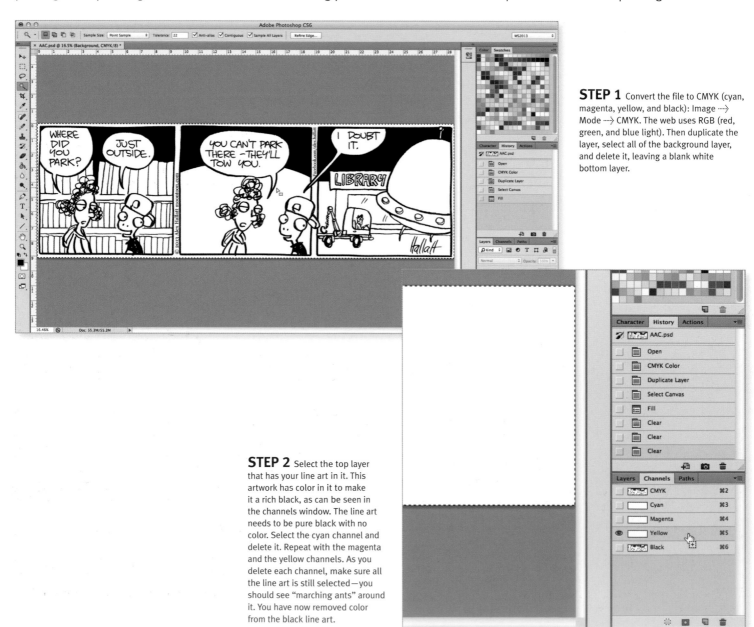

STEP 1 Convert the file to CMYK (cyan, magenta, yellow, and black): Image ⸱⸱⸱⸱➔ Mode ⸱⸱⸱⸱➔ CMYK. The web uses RGB (red, green, and blue light). Then duplicate the layer, select all of the background layer, and delete it, leaving a blank white bottom layer.

STEP 2 Select the top layer that has your line art in it. This artwork has color in it to make it a rich black, as can be seen in the channels window. The line art needs to be pure black with no color. Select the cyan channel and delete it. Repeat with the magenta and the yellow channels. As you delete each channel, make sure all the line art is still selected—you should see "marching ants" around it. You have now removed color from the black line art.

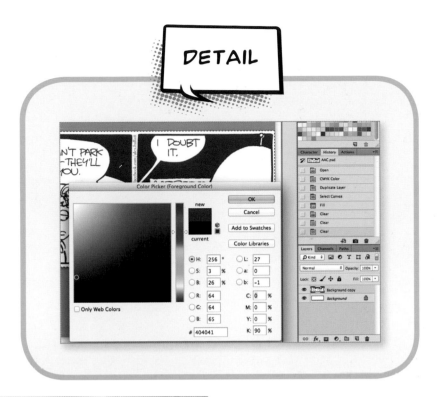

DETAIL

STEP 3 Select the top "CMYK" in the channels window and switch back to the layers window. If you check the line art color with the eyedropper tool, you can see that it has no color—only 90% black (see detail). It needs to be 100%. One way to do this is to adjust levels. Select Image ⟶ Adjust ⟶ Levels and drag the left (and middle) pointer all the way to the right. When you check the black with the eyedropper, you'll see it is now 100%.

STEP 4 You will color underneath the black line, which means that you need to make the areas of white transparent. Change the layer from "Normal" to "Multiply" in the layer window.

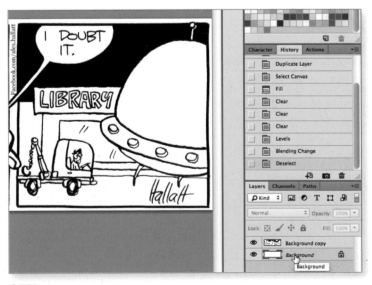

STEP 5 You can now deselect and click on the bottom, background layer, which is the layer you will color.

COLORING

ARTIST'S TIP

You can build up a color palette to save these colors for future strips. Your color palette is another part of your strip's unique look.

STEP 1 Use the color picker to select colors, but make sure they contain no black (0% K) and aren't oversaturated with color (to prevent color bleeding on the page).

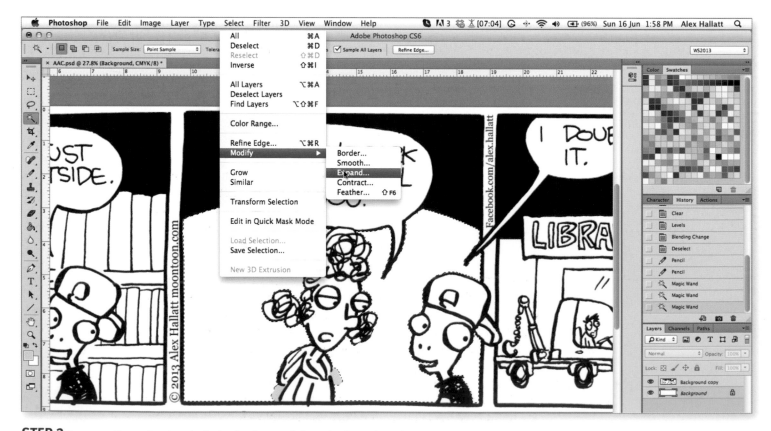

STEP 2 You can use the pencil tool to color freehand or close gaps before using the magic wand to select the area(s) to color. Expand 4 pixels so that the black line overlaps the edges of the color area.

If you want your comics to appear on the web too, first convert them to RGB color. Then resize the file to a lower screen resolution (usually between 500 and 1000 pixels wide). Save them as GIFs, which are better for areas of flat color than JPEGs.

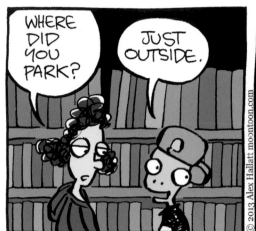
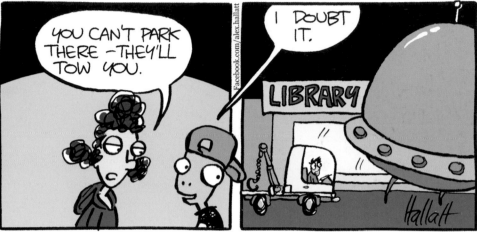

STEP 3 Fill with the foreground color, deselect, and repeat until the strip is complete.

When I finish a strip, I save the large Photoshop file before reducing it to print size, flattening the layers, and saving a copy as a TIFF to send to my syndicate for distribution to newspapers.

DISTRIBUTION

Syndicates like mine only launch two or three new features a year, so competition is tough! If you do want to try this route, check the submission guidelines at the syndicate website and be sure to follow them. If you're accepted, a syndicate markets and sells your cartoon into newspapers, websites, and other outlets. They handle the distribution of the strips you send them and the collection of any revenue.

Even if you would like to be syndicated, it also makes sense to publish your work online as a web comic and use this distribution outlet as a way to develop, test, and refine your comic. Many web cartoonists are as successful as, or even more successful than, syndicated cartoonists. A key difference is that web comics are usually given away for free, with money being made on associated merchandise such as printed books, t-shirts, etc.

However you choose to distribute your comic strip, remember that it takes time to build an audience. If you provide good content on a regular schedule, you have a good chance of entertaining a lot of readers. And that's a great reward.

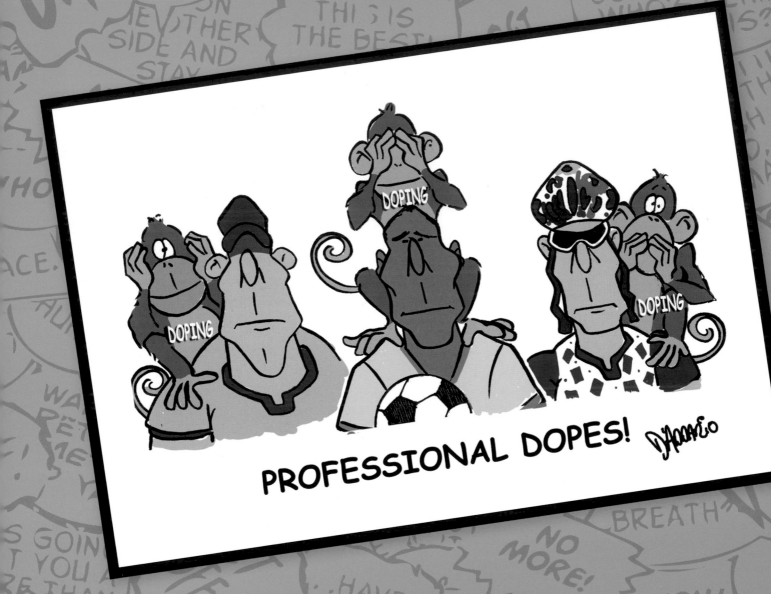

CHAPTER 5

EDITORIAL CARTOONS

WITH DAN D'ADDARIO

Sometimes called "political cartoons," editorial cartoons are humorous, satirical illustrations or comic strips based on a political or social message. Typically these cartoons relate to current events or personalities, but they can also be created around historical events or figures of the past. Nearly every major daily newspaper features an editorial cartoon on its opinion page, and they are used to highlight a significant aspect of a news item.

A good editorial cartoon expresses the opinion of the cartoonist and prompts the reader to think about the subject. A lot more goes into editorial cartooning than just good drawing skills!

In this chapter you'll explore some generic editorial cartoon ideas, designed to help get your creative juices flowing so that you can come up with your own current editorial cartoons based on what is happening in the world around you. So put on your thinking cap and let's get started!

THE PROCESS

Developing an editorial cartoon requires a couple of extra steps and provides a fun, creative challenge. From conception to execution, let's walk through the stages of developing a successful editorial cartoon.

ASSIGNMENT

Follow along with me! Before moving on to the next step, research your own ideas. Brainstorm at least three and pick one to complete as an editorial cartoon.

YOUR LOCAL NEWS IS NEXT

STEP 1 Before beginning an editorial cartoon, I find a good article or news story to start from.

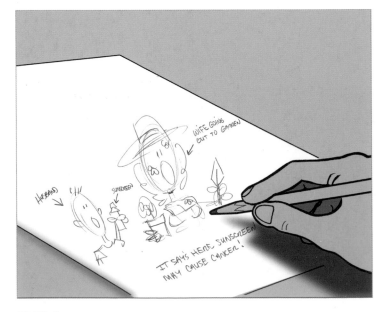
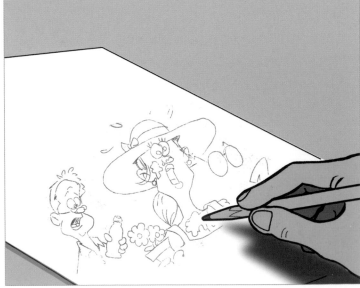

STEP 2 I sketch out some rough ideas to send to the editor. Once the editor selects a rough I start my pencil sketch, detailing the cartoon.

STEP 3 When my pencil sketch is complete and I'm happy with the composition and layout, I rub a carbon stick on the back of the paper.

STEP 4 Then I transfer my sketch onto 110-lb. white card index paper.

STEP 5 I ink over my pencil lines using a brush marker and permanent black markers.

STEP 6 Then I scan my cartoon into my computer for coloring.

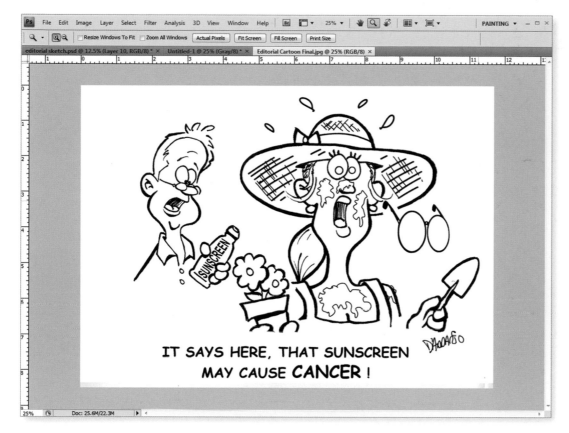

STEP 7 Once scanned into my computer I open the file in Photoshop to color.

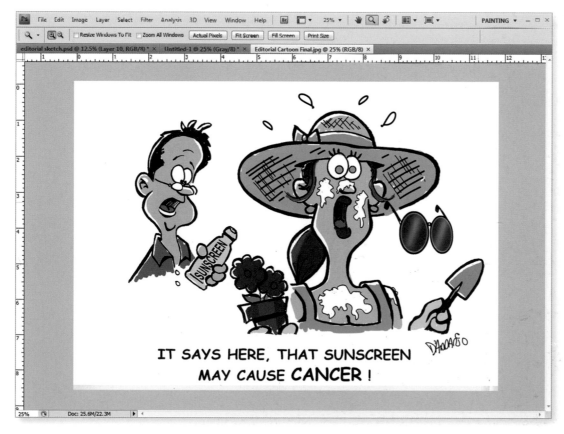

STEP 8 I finish my cartoon by adding color!

AT THE MOVIES

As mentioned in the introduction to this chapter, editorial cartoons are often also called "political cartoons." Politics are perfect fodder for satirical comics and are a good, consistent flow of ideas and topics. This is also a sensitive subject, however. Be judicious in how you choose to approach controversial topics.

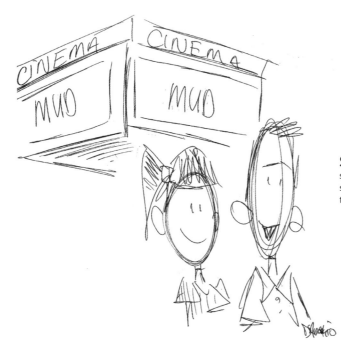

STEP 1 First I develop several ideas and send some rough sketches to the editor.

I THOUGHT THE MOVIE WAS GOING TO BE ABOUT DEMOCRATS AND REPUBLICANS DEBATE!

STEP 2 Once the editor chooses an idea I start developing the cartoon and send it back for approval and changes.

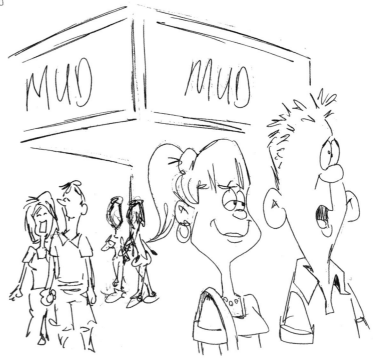

I THOUGHT THE MOVIE WAS GOING TO BE ABOUT DEMOCRATS AND REPUBLICANS DEBATE!

ARTIST'S TIP
Use a ruler to get perfectly straight lines like those on the theater sign.

STEP 3 After I receive final approval for the cartoon, I begin working out my final pencil drawing.

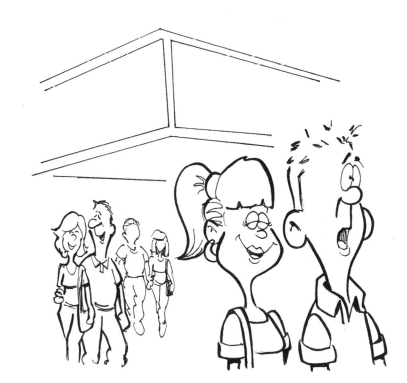

STEP 4 I apply graphite to the back of my final pencil sketch and transfer it to heavy card stock for inking.

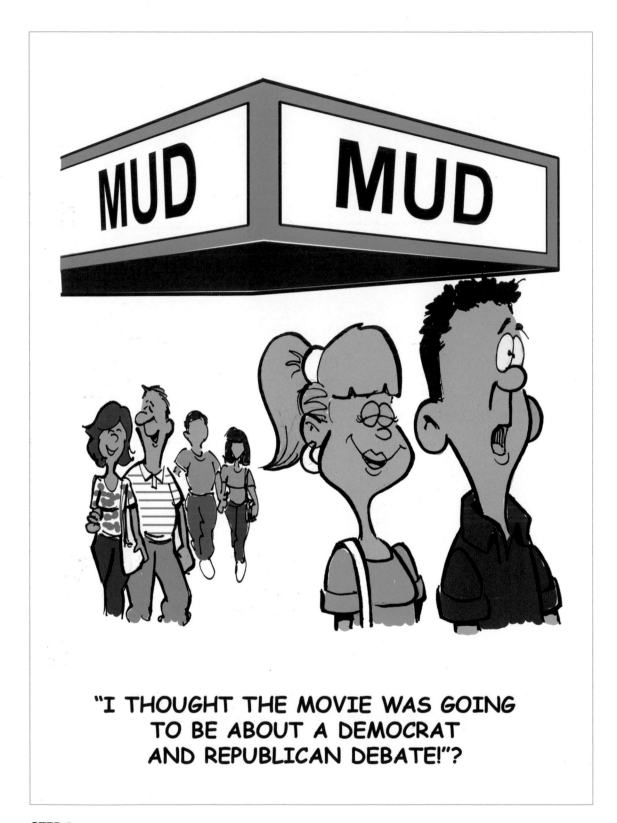

STEP 5 Once the cartoon is inked I scan it into Photoshop and begin adding color.

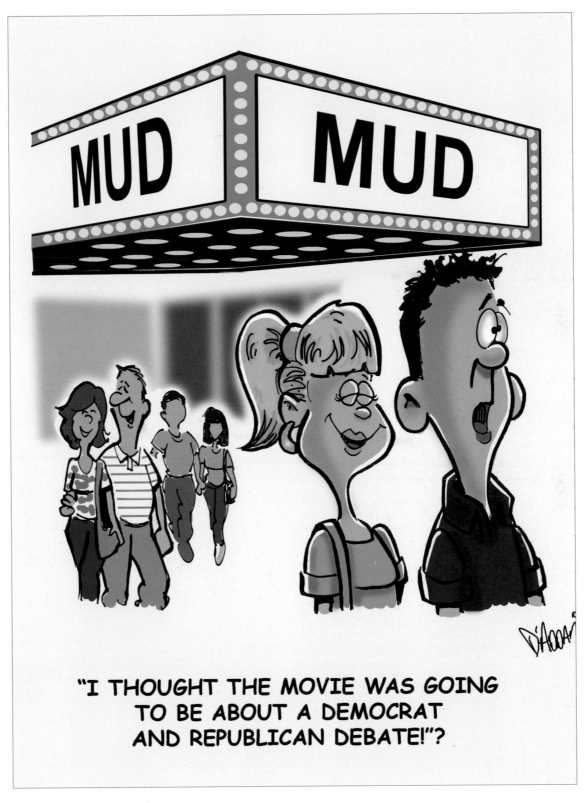

STEP 6 I finalize the cartoon with background details, lettering, and shadows and highlights.

PENGUIN DECLINE

Universal topics, such as global warming or animal extinction, make good topics for editorial cartoons. They are easy to understand and don't require any special knowledge about a specific event, person, or news story.

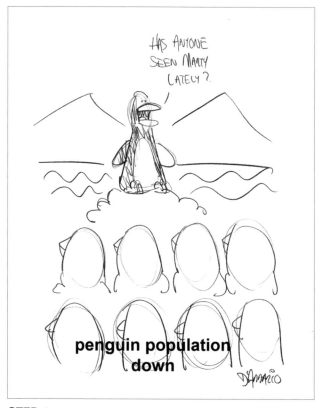

STEP 1 First I draw a rough sketch of my initial idea.

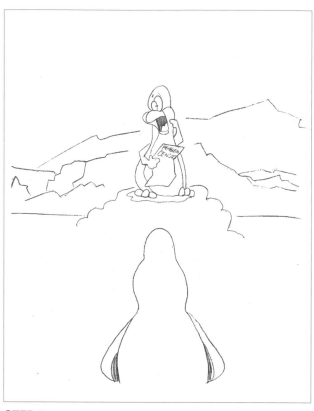

STEP 2 Once my idea is approved, I pencil the final look of the cartoon. In this case I only draw one penguin in the foreground. After I have inked and scanned my cartoon I'll copy him multiple times to make it look like a crowd of penguins.

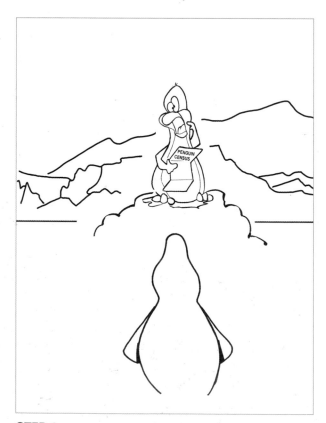

STEP 3 When I'm happy with my line drawing I ink the final cartoon and erase any unwanted lines.

STEP 4 When the ink is dry I scan the cartoon into my computer and digitally color it.

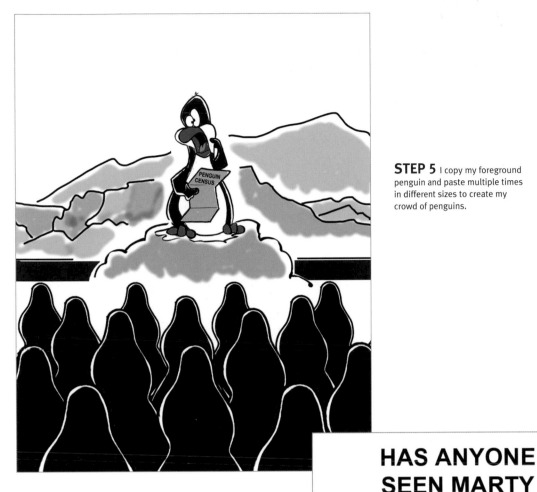

STEP 5 I copy my foreground penguin and paste multiple times in different sizes to create my crowd of penguins.

STEP 6 To finish, I simply add the wording and sign my name.

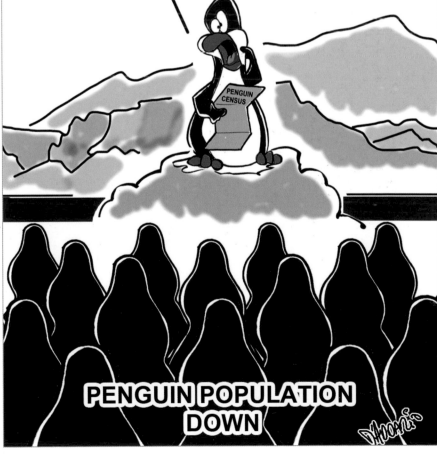

PROFESSIONAL DOPES

Editorial humor is best served by simple illustrations that don't require a lot of detail to send a message. In this project, notice how simple the features of the three characters are. Minimal details, such as their outfits, and a simple line of text go a long way in expressing a message about a hot topic in professional athletics.

STEP 1 I begin with a rough sketch of my idea.

STEP 2 After the sketch is approved, I make my pencil drawing.

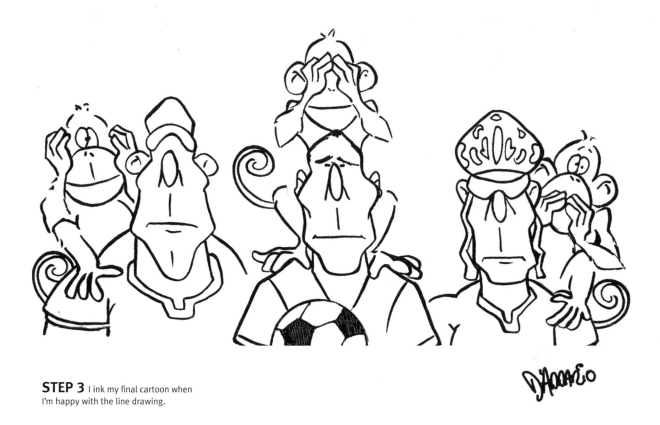

STEP 3 I ink my final cartoon when I'm happy with the line drawing.

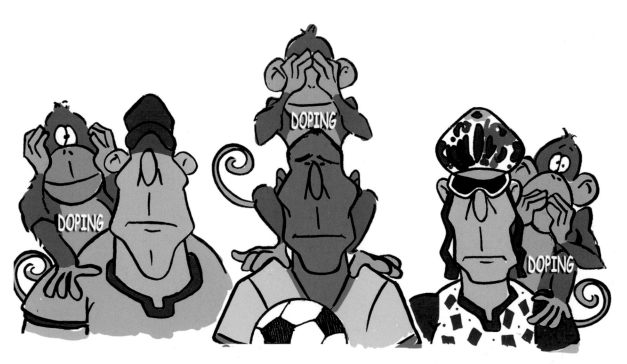

PROFESSIONAL DOPES!

STEP 4 I scan my inked cartoon into my computer and color it. Then I add the text as the finishing touch.

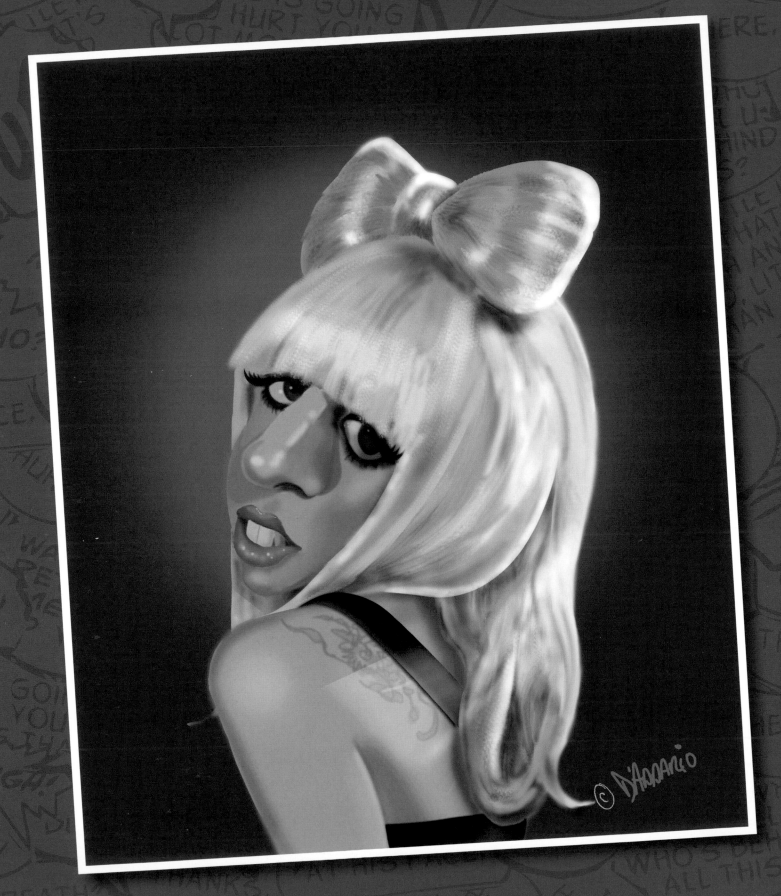

CHAPTER 6

CARICATURES

WITH DAN D'ADDARIO

The art of caricatures is all about exaggeration. This fun, amusing art form allows the artist the opportunity to intentionally distort the subject by highlighting—or exaggerating—a unique feature. The secret to a great, recognizable caricature is to understate minimized features on your subject and exaggerate their most recognizable feature.

In this chapter you'll learn how to draw four celebrity caricatures. Famous people are instantly recognizable and great subjects for caricatures, but you can draw a caricature of anybody! After completing the projects in this chapter, try drawing caricatures of your friends and family—or even your mailman!

ANGELINA JOLIE

What's the first thing you notice when you see a picture or film with Angelina Jolie in it? It's likely her large lips. But she also has some other defining characteristics, such as defined cheekbones, big eyes, and a long neck. In this caricature I even draw her standing in a pose that some may recognize from an entertainment-industry award show.

STEP 1 I start by drawing the pose with very simple circles and lines—it's like connecting the dots!

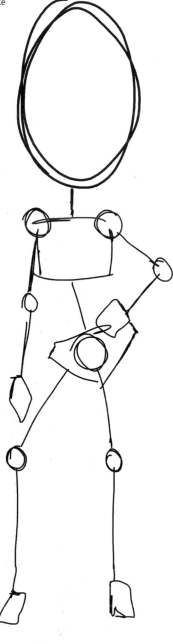

STEP 2 Then I start forming the body parts and limbs by working around my circles and lines. As I work I erase the guidelines that I no longer need. I add guidelines to the head to mark the placement of facial features.

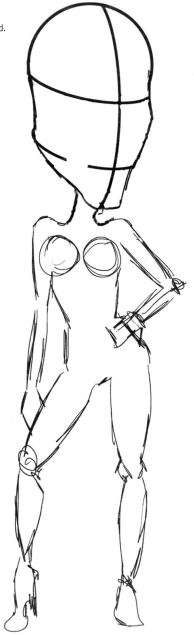

STEP 3 Once I have the body shape in place, I add the dress around her figure. I sketch in eyebrows and the basic shape of the eyes, nose, and mouth.

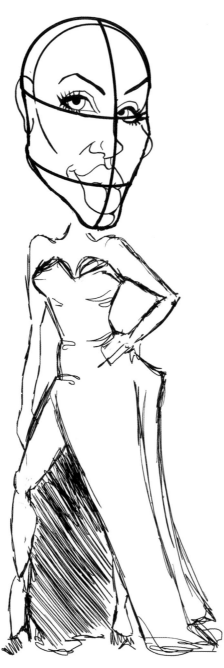

STEP 4 I erase my guidelines and make any tweaks. I add some lines to define her cheekbones. I also detail the ear.

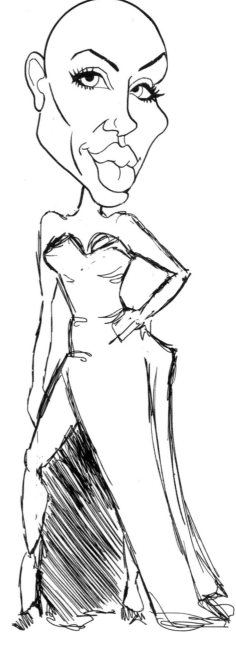

STEP 5 I draw several shapes to outline long, flowing hair. I clean up my lines to finalize my line drawing. Then I scan it into Photoshop to add color.

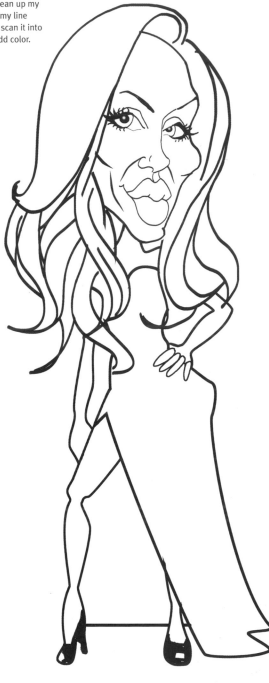

STEP 6 I start by adding just solid colors to all areas of the figure. I chose a deep midnight blue for the dress.

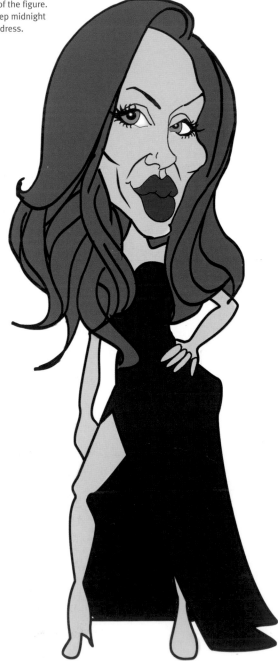

STEP 7 To finish, I add shadows and highlights, using lighter and darker shades of my original colors to create both. I also add some pure white highlights in the eyes and on the lips.

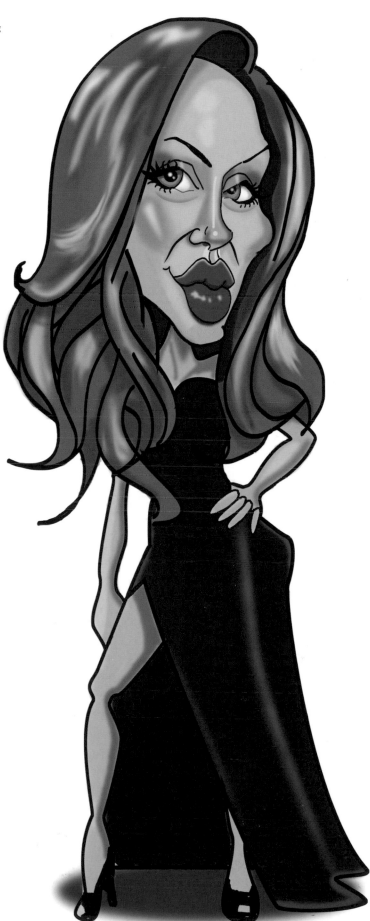

JUSTIN BIEBER

This teen heartthrob is known for his pouty lips and infamous hairstyles. In this project I mostly emphasize the hair and lips, but I also subtly exaggerate Justin's long, angular face.

STEP 2 Next I place the large, round eyes, along with the nose and pouty lips. I add the ear and also bring in the jutting jaw and rounded chin.

STEP 1 I start by sketching an oval shape for the cranium and a long rectangle for the face. Then I draw in the guidelines for the eyes, nose, and mouth. I also roughly sketch the shape of the neck and shoulders.

STEP 4 Now for Justin's most recognizable trademark feature—the hair! I sketch a tidal wave pompadour on the top of the skull.

STEP 3 Time to add some detail. I sketch in the heavy eyebrows and define the shapes of the eyes, adding lids, eyelashes, and irises. I also refine the shape of the round part of the nose and develop the lips more. The shape on the cheek helps me visualize the cheekbone.

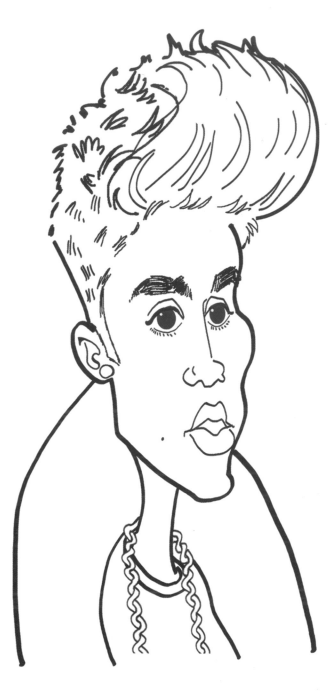

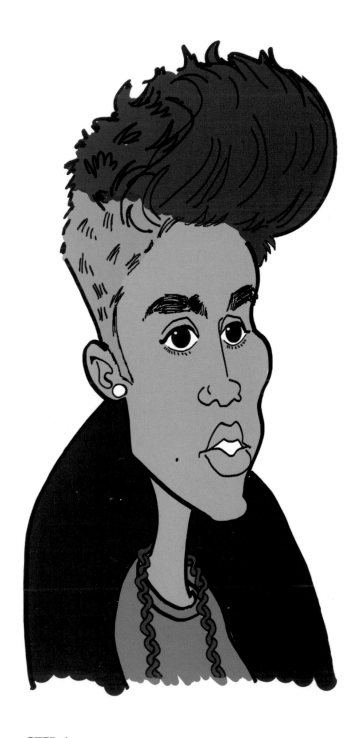

STEP 5 I erase the guidelines from the face and head. Then I add detail and swooping lines to the pompadour and work on refining the details in the eyes and nose. I also finalize the lines for the neck and shirt. I add an upside-down "U" behind Justin for a big coat collar. Then I add a chain necklace, using a relaxed "S" for each link. When I'm happy with my drawing, I scan it into Photoshop for coloring.

STEP 6 With my drawing open in Photoshop, I select the brush tool and the color black and trace my scanned drawing. Then I select a middle skin tone and apply to the face and neck. I choose brown for the top of the pompadour and tan for the bottom. I use black for the coat and gray for the shirt.

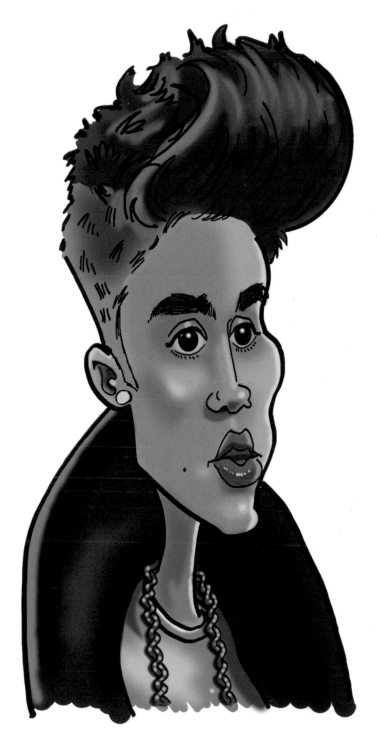

STEP 7 I apply a layer of muted pink-red to the lips and finish off my caricature by adding details, shadows, and highlights. To add the shadows and highlights, I use the airbrush tool from the brush palette and move about the image, lightening and darkening for dimension.

LADY GAGA

Lady Gaga may be most well known for her interesting outfits, but in this caricature I only want to focus on her physical features. I keep her in a simple black dress, glancing over her shoulder. This pop star has lots of tattoos, so I'll include one on her shoulder, as well as a signature "bow" in her hair.

STEP 1 I start with a circle for the head and draw curved lines ending at a squared-off triangle for the chin. This is a three-quarter view. I add curved lines where the eyes, nose, and mouth will fall. Then I draw the body.

STEP 2 Next I add ovals for the eyes and a few simple lines for the nose and mouth.

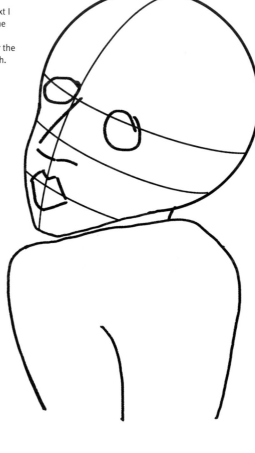

STEP 3 Now I start adding some details. I fill in the eyes with large pupils and heavy lashes. I refine the shape of the nose and mouth, separating the lips and teeth. I erase my guidelines.

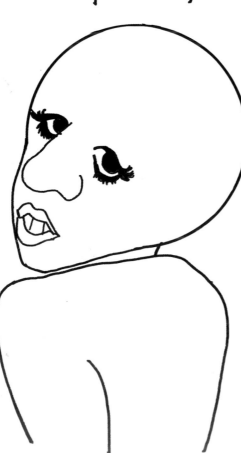

STEP 4 Next I add her hair, with a big bow on top of the head. Again, I'm just using simple lines to block in the shapes. Then I draw a tattoo on her left shoulder.

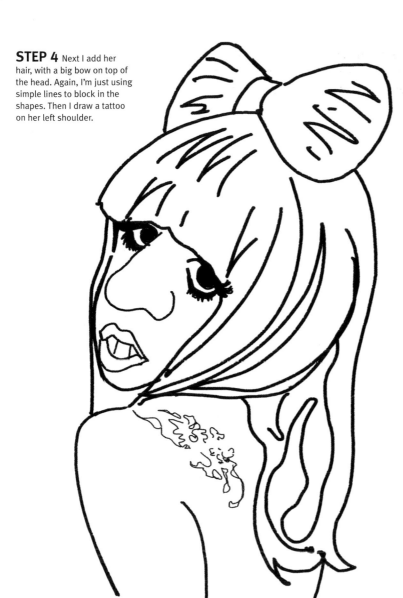

STEP 5 I scan my drawing. Then, instead of making my lines black, I change the lines on the hair, face, and body to the colors that I will make them.

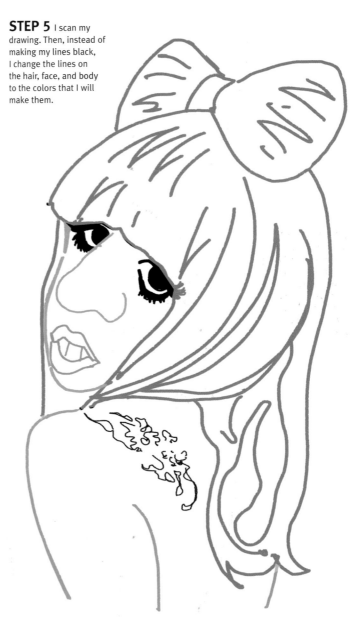

STEP 6 I add solid midtone colors on the hair, face, and body. Then I add the back and strap of a black dress.

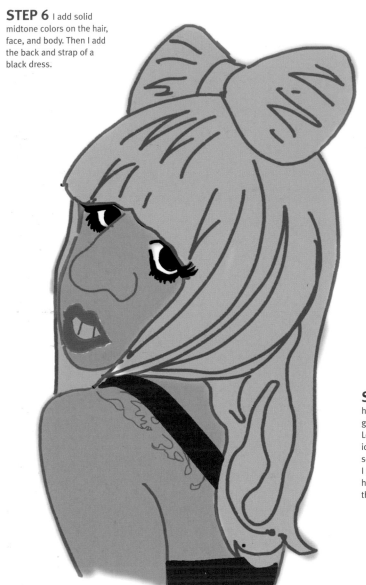

STEP 7 Next I bring in highlights and shadows to give my caricature dimension. Look closely at this step to identify where you can still see my original midtones. I also add in the iris and highlights in the pupils in the eyes.

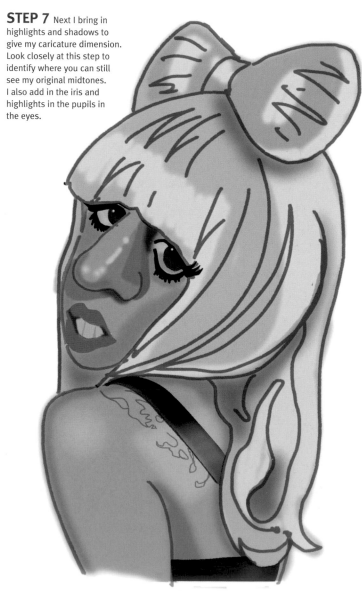

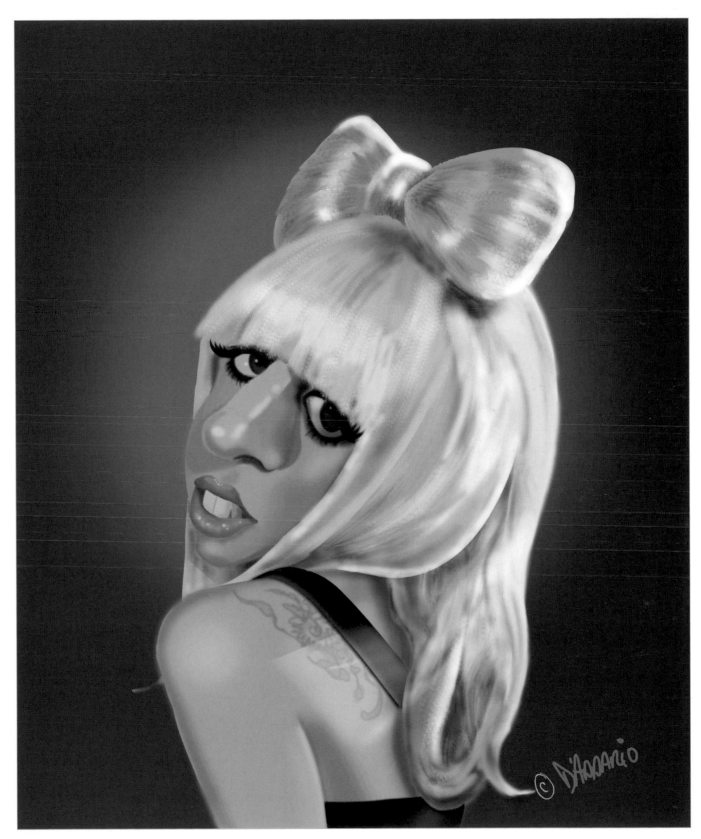

STEP 8 I add a brown background with a feathering white, radial gradient behind Lady Gaga's head. To finish, I add some extra tiny highlights to the lips and fill the tattoo design with a light color.

MORGAN FREEMAN

Unlike most celebrities, Morgan Freeman is instantly identifiable by voice alone. But this well-known actor is also recognizable by his freckles, large nose, and curly gray hair and beard.

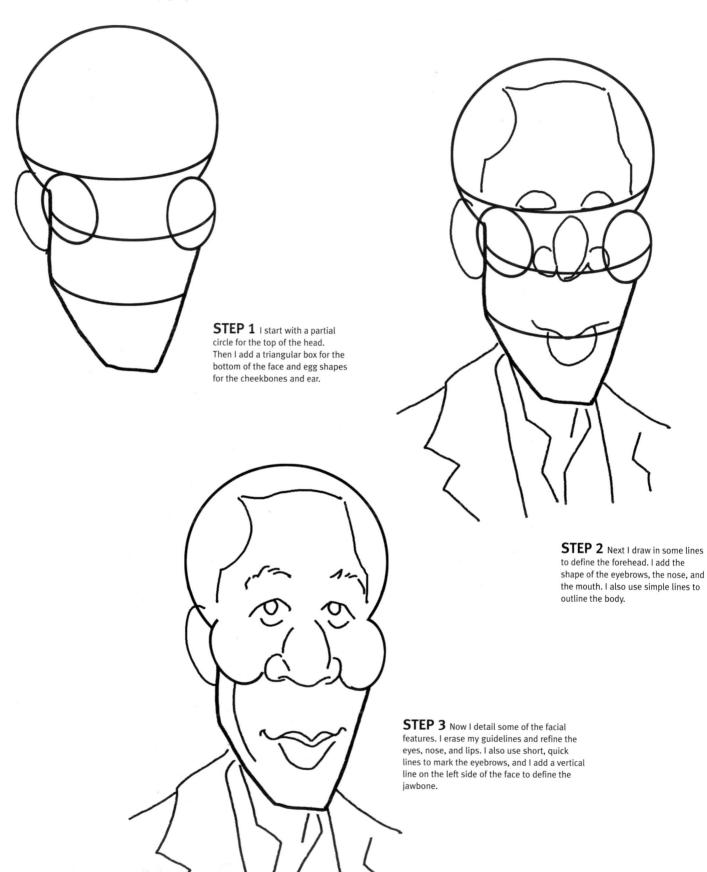

STEP 1 I start with a partial circle for the top of the head. Then I add a triangular box for the bottom of the face and egg shapes for the cheekbones and ear.

STEP 2 Next I draw in some lines to define the forehead. I add the shape of the eyebrows, the nose, and the mouth. I also use simple lines to outline the body.

STEP 3 Now I detail some of the facial features. I erase my guidelines and refine the eyes, nose, and lips. I also use short, quick lines to mark the eyebrows, and I add a vertical line on the left side of the face to define the jawbone.

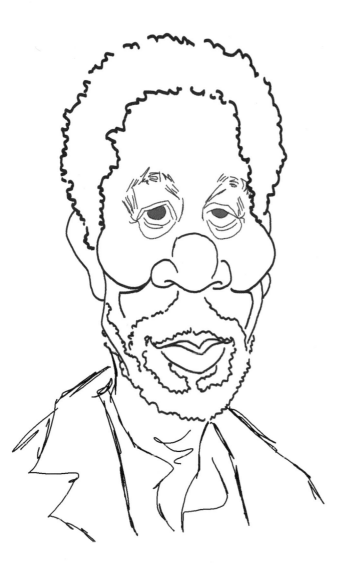

STEP 4 I add wavy lines for the hair, beard, and mustache. Then I add even more detail to the eyes, darkening in the irises and drawing in the lids and puffy under-eye area. I add more sketch lines for the eyebrows, and then I add just the hint of the other ear on the right side of the face.

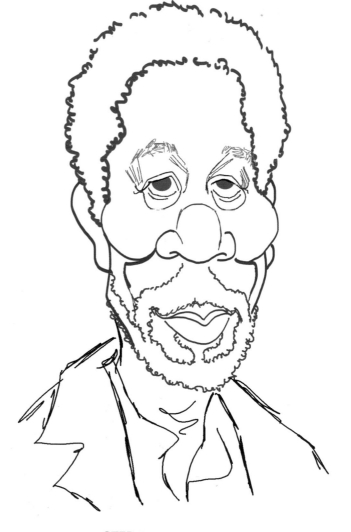

STEP 5 I scan my drawing into Photoshop. Then I change the outlines for the hair, face, and body to the colors I want to use in each area.

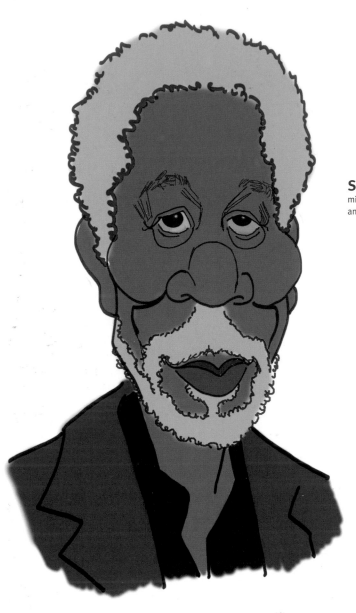

STEP 6 Next I add solid midtones to the face, hair, shirt, and jacket with the brush tool.

STEP 7 I add highlights and shadow tones. I also add a gold hoop earring, his characteristic freckles, and wrinkle lines to the forehead. I use the line segment tool to draw straight, light blue lines on the suit jacket.

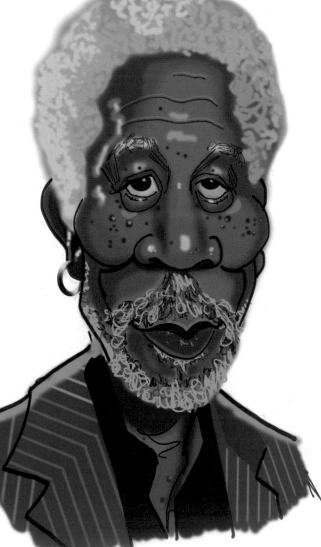

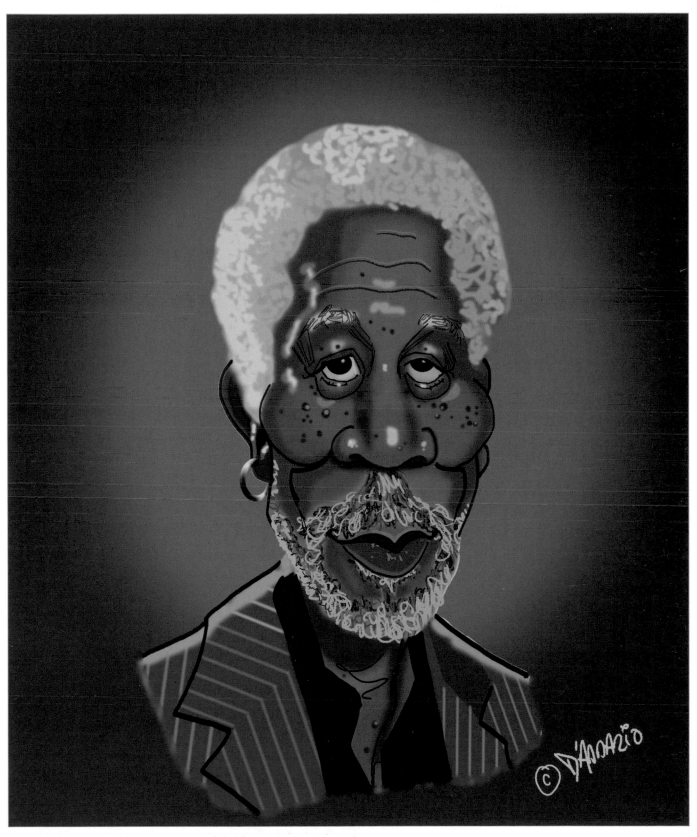

STEP 8 I finish my caricature by adding a dark gray background with a light gray gradient sphere behind his head.

ABOUT THE ARTISTS

MAURY AASENG has always been excited about drawing and art. After graduating with a BFA in graphic design from the University of Minnesota—Duluth, Maury began an illustration career, and his freelance work over the last eight years has spanned a variety of subject matter and illustration styles. In 2010, Maury's artwork was featured in the Upstream People Gallery 7th Annual Color: Bold/Subtle Juried Online International Art Exhibition. An avid nature enthusiast, Maury lives in Duluth, where he supplements his illustration work with wildlife photography and painting and enjoys hiking, skiing, and canoeing in the northern forests that border Canada. Visit www.mauryillustrates.com to learn more.

CLAY BUTLER has been working professionally as an illustrator and cartoonist since 1984. After honing his chops as a staff editorial cartoonist for several local papers in the early 90s, he channeled his ambitions over the next decade into *Sidewalk Bubblegum,* his weekly, self-syndicated alternative political comic strip. His illustration work for *Playboy* magazine and extensive work as a storyboard artist for Discovery Channel, Animal Planet, Disney, and Google further sharpened his theories about how the mind interprets graphical information and how to shape an engaging narrative. Visit www.sidewalkbubblegum.com to see his legendary strip or www.claytowne.com to view more of Clay's work.

JIM CAMPBELL is a professional comic-book letterer, one-time writer (perhaps again in the future), and occasional artist—although his enthusiasm rather outstrips his actual ability. He knows more about print production than mortal man was meant to know and has scanned more images than you've had hot dinners. Unless you're ninety years old. Visit www.jimcampbell-lettering.co.uk to learn more about Jim.

DAN D'ADDARIO has been drawing as far back as he can remember. It wasn't until college that one of his art instructors encouraged him to try doing caricature drawings for a high school graduation party in 1977. He was hooked and hasn't looked back since! Dan's resume consists of a career spanning almost 30 years as a graphic designer in the automotive field, all while pursuing his passion of caricatures and cartooning. From 1996 until 2008, Dan was a freelance editorial cartoonist for Crain's *Detroit Business* magazine. Currently Dan is pursuing a career as a freelance illustrator and caricaturist. Visit www.dandcaricatures.com to learn more.

ALEX HALLATT is a freelance cartoonist and writer based in the UK, with clients in the US, New Zealand, Australia, and the UK. She provides cartoon illustrations for newspapers, books, and magazines, and has created flash animations for advertisements, games, corporate presentations, e-cards, and websites. Alex's comic strip, *Arctic Circle*, is distributed worldwide by King Features Syndicate. Visit www.moontoon.com to view more of Alex's work.

JOE OESTERLE is an award-winning writer and illustrator, but what he often fails to mention is that many of those awards were won on a New Jersey boardwalk, shooting a water pistol into the mouth of a plastic clown in an effort to be the first to pop the balloon. He has worked as Art Director for the Teenage Mutant Ninja Turtles apparel division and performed double duty as Art Director and Senior Editor at National Lampoon. His work has appeared in television, radio, books (including *Weird Hollywood* and *Weird California*), magazines, and websites. Among his achievements, Joe is especially proud that a humorous animated short he wrote, directed, and voiced has been on display at the Smithsonian Institution since 2001. Visit www.joeartistwriter.com to learn more.